Easy Watercolor

Learn to Express Yourself

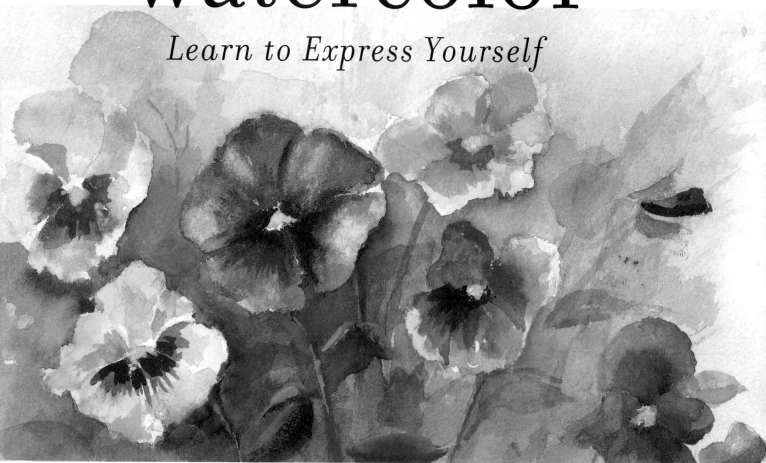

Marcia Moses

STERLING PUBLISHING CO., INC.

NEW YORK

EDITED BY JEANETTE GREEN
DESIGNED BY JUDITH STAGNITTO ABBATE

Library of Congress Cataloging-in-Publication Data Available

10 9 8 7 6 5 4 3 2 1

Published by Sterling Publishing Co., Inc.
387 Park Avenue South, New York, N.Y. 10016
© 2002 by Marcia Swartz Moses
Distributed in Canada by Sterling Publishing
c/o Canadian Manda Group, One Atlantic Avenue, Suite 105
Toronto, Ontario, Canada M6K 3E7
Distributed in Great Britain and Europe by Chrysalis Books
64 Brewery Road, London N7 9NT, England
Distributed in Australia by Capricorn Link (Australia) Pty Ltd.
P.O. Box 704, Windsor, NSW 2756 Australia
Printed in USA

Sterling ISBN 0-8069-9542-4
Cover and title page: Winter Pansies, Marcia Moses, 8 × 10 inches

WITH ALL MY HEART, I dedicate this book to my mother,
Marguerite Welsh Swartz, who gave me the courage to pursue my dreams.
I know that you're that angel on my shoulder still protecting and guiding me.
I love you; this song is for you.

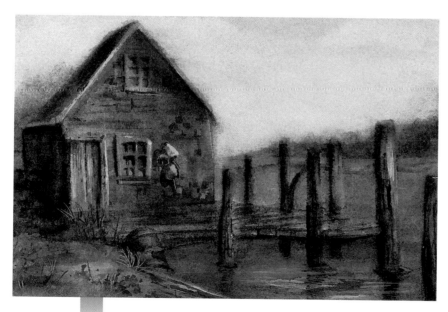

Menemsha
Marcia Moses, 11×14 inches

The Soulful Life

I don't care to know how much knowledge you've acquired
 nor countries traveled;
I want to know if you've given your soul a place to live.

Does your spine shiver over a wise poet's words of grace?
Do you commune with nature long and with tireless wonder?
Have you known despair and dared to sit fully into the fire,
 transforming your terror into that of a trusted friend?

Can you thrill over a star-streaked sky of night, tenderly wipe
 away a young child's tears, or marvel over the majesty of
 an artful masterpiece?

Are you a dreamer by day? A lover of night?
Does your own vast potential fill you with awe?
Do dreams of a peaceful world arouse you to ascending heights
 of hope?

Does the mystery of the universe excite you beyond measure,
 and can you feel the presence of a power greater than
 yourself in all of your affairs?

Then join me on the path of wonder, and I'll meet you in a
 field of infinite possibilities.

—DIANA LOOMANS

Contents

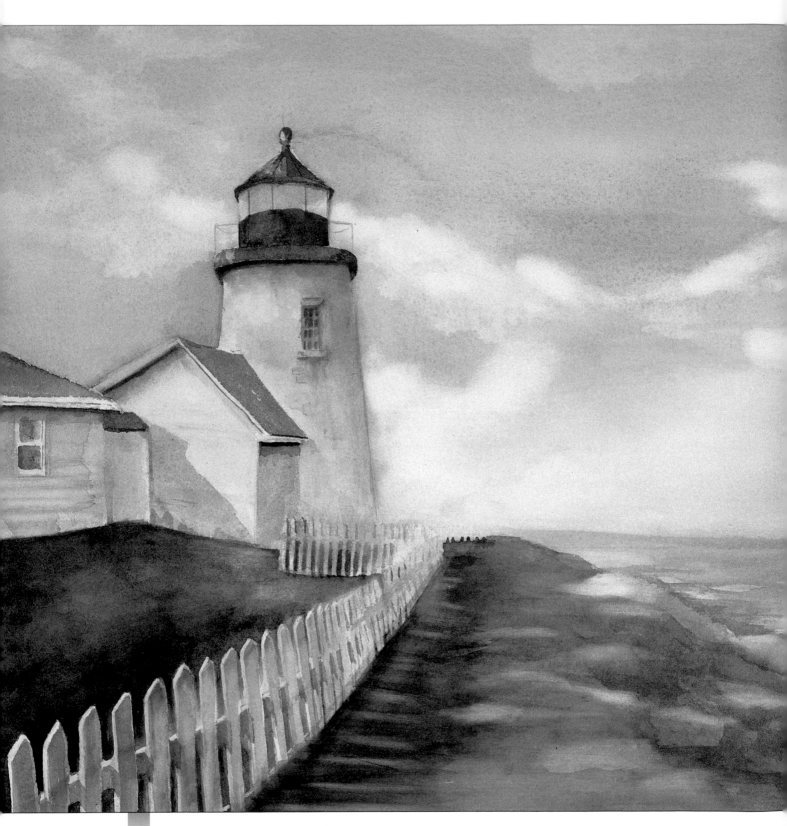

Pemaquid Point
Marcia Moses, 22×30 inches

Foreword

PASSION, ENERGY, AND SINCERITY are the words that best describe Marcia Moses's commitment and contribution to watercolor and art.

When I first met her in 1997, Marcia was known as the "lighthouse lady." For many years, lighthouses were often featured in her art. She visited each new lighthouse, learned its history, and studied it intimately. She observed minute details, even noting the kind of lamp, lumens of light, and the how many revolutions it made per minute.

She brings knowledge, conviction, and zeal to new watercolors. Marcia is a true professional with unlimited energy devoted to her art. Her paintings of flowers, seascapes, and landscapes capture a mood that reflects her very personal appreciation of nature.

As a top watercolor instructor, Marcia has dedicated herself to teaching many students across the country. The same vision that Marcia embodies in her paintings is instilled in this book. You'll enjoy these easy lessons and be inspired by the watercolors in each chapter. Happy painting!

—LEN GARON

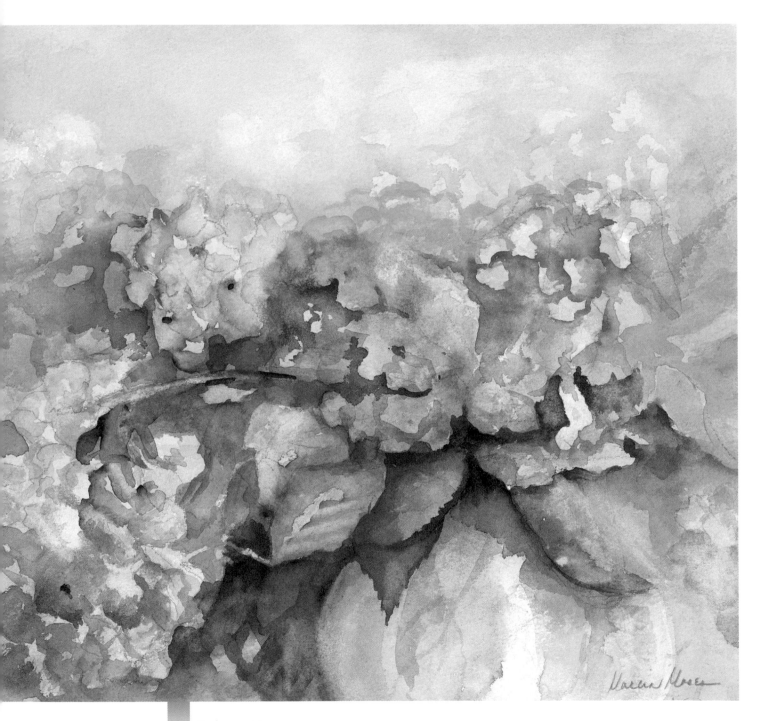

Hydrangeas
Marcia Moses, 22×20 inches

Introduction

PAINTING IS LIKE SINGING. When we sing, we relate to the audience with music and verse. In painting, we relate to the viewer with an aesthetically pleasing and meaningful arrangement of elements on paper.

In this book, I hope to share the joy I feel when achieving a desired artistic effect and want to show how you can put your heart on paper. In my art, I have found a place for my soul to live, and I want you to discover that place, too.

Desire is the driving force behind art. If you have desire, you can accomplish any goal you envision. That desire, however, must come from within. You can learn a watercolor technique or be knowledgeable about art and art history, but you'll need the desire to develop and use new skills or try out a different technique in order to succeed. When a student tells me, "I can't do that!" I simply reply: "You are right! If you think you can't, then you really can't." I believe that anyone who really wants to paint can.

Sometimes we pay a price to realize a dream. If your desire is strong enough, the price is small compared to the result.

French painter Claude Monet (1840–1926), like many other great artists, decided to dedicate his life to art, and he paid the price with rejection, endless hours of study, and years of financial struggle. His needs were grounded in the pleasures he found in nature, his gardens, his domestic life, and in the spiritual and ethereal realms of his art. His desire to create a masterpiece superseded other needs. He was happy, however, because he lived out his dream and expressed his art in spite of the price. It's important to understand that desire keeps the dream alive. You'll find passion when you finally know in your heart and soul that you can have what you truly want. The price you pay will be small in comparison to the dream you achieve.

Keep reaching! Don't stop! Never give up on your dream! We all want to sing out to the world from the heart, mind, and soul; this is my song. I hope that you discover yours.

—MARCIA MOSES

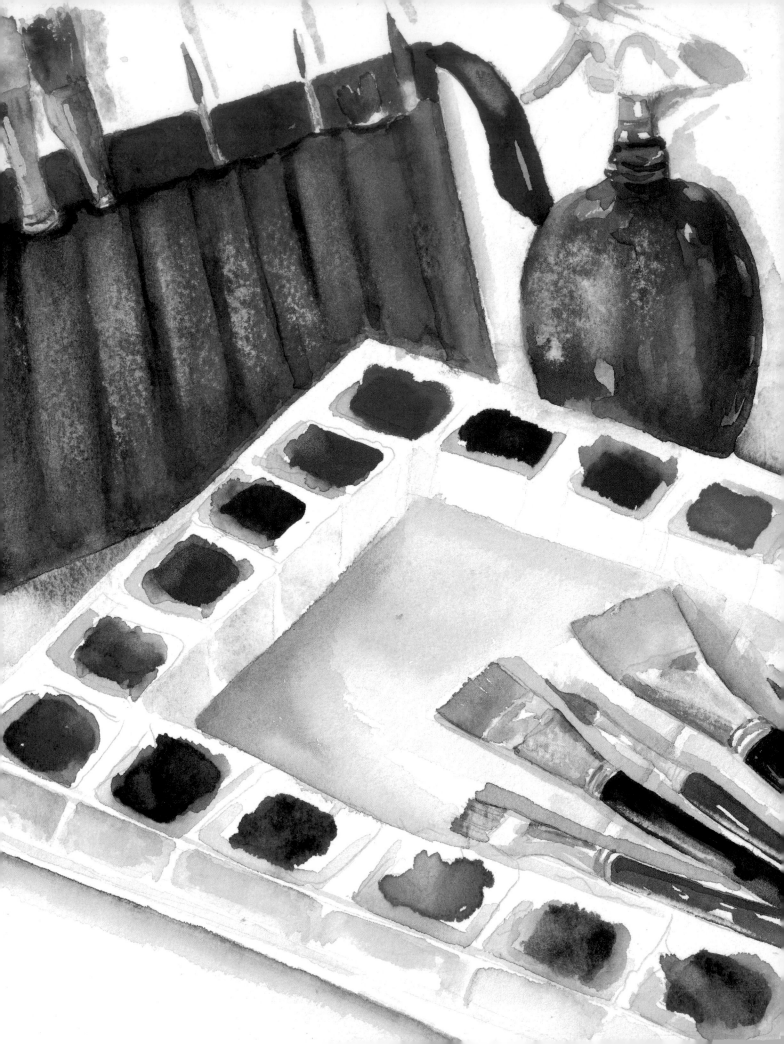

Finding the Right Tools & Materials

FINDING JUST THE RIGHT watercolor tools and materials for me took many years of painting and experimenting.

I can advise you about what materials are best for a beginner to work with, but personal likes and dislikes and individual artistic styles play a large part in each artist's selection. So I urge you to experiment on your own. Find out which brushes you feel comfortable painting with and what paints help you achieve the artistic results you wish. Don't think of it as a chore; think of it as playing. You'll be painting through the selection process.

PAPER

MANY DIFFERENT TYPES of watercolor paper are available, and each has a distinct use. The three most popular types of watercolor paper are hot-pressed (HP), cold-pressed (NOT), and rough. In the past artists needed to "size" paper, often by soaking it briefly. Today most paper is of such quality that artists don't need to do that anymore.

- **Hot-pressed paper,** referred to as HP, is smooth, without a lot of texture.
- **Cold-pressed paper** is also called NOT, which means not hot-pressed. It isn't as smooth as hot-pressed paper and has a little texture.
- **Rough paper** is exactly what it claims to be, paper with lots of texture. It allows paint to fall into its many valleys, leaving the peaks without color.

ROUGH

HOT-PRESSED

COLD-PRESSED

ARTIST'S TIP

Always store paper in a flat position to prevent curling.

I use 140-pound Strathmore Imperial, 140-pound Strathmore Gemini, and 140-pound Arches for most of my work. All of these papers are cold-pressed. They all take a beating. Paint can be dabbed off them, rubbed off them, and scrubbed off them without much damage to the paper itself. Mistakes can be corrected. They're all very forgiving papers.

However, subtle differences in these papers can be used to achieve your artistic goals. Arches cold-pressed paper has a somewhat forgiving surface, but Strathmore Imperial is even more forgiving. Strathmore has a quality that makes it easier to lift paint from its surface and to get back to the paper's white color. If you plan poorly and inadvertently paint an area that you had intended to leave white, you can take a damp brush and lift the paint off and return to the desired lighter value.

While Strathmore Gemini is very similar in surface to Arches, it has a creamy tone. An artist preserving whites must be aware that those whites will not be as bright as when using some other papers.

Beginners also need to look for a better quality of paper than they might initially want to buy. They think, "I'm just starting out, so I'll practice on cheap paper." However, beginner "mistakes" are exactly why you should choose better-quality paper. (I feel that there really are no real mistakes—just happy accidents that can be turned into new directions.) I'd suggest using at least 140-pound paper because it's going to hold up especially when you want to scrub the paint off. The only reason a beginner might want to use a rough

paper is to take advantage of its skipping power. With rough paper, the brush will skip over small sections and miss certain parts of the paper, leaving a sparkling appearance.

Hot-Pressed or Cold-Pressed?

Hot-pressed paper accepts a smoother wash and can be used, for example, when painting a misty landscape. Paint soaks into the paper in a smooth, non-textured manner. Cold-pressed paper is the most versatile. You can do just about anything on it.

Paper Size

What size of paper to use is also an obvious question for the beginner. The usual advice for novices—start small—may not apply to people beginning to learn watercolor art. Granted, a beginner won't want to start with a full 22×30 sheet of paper. An entire blank sheet of paper can be intimidating no matter how large. But, it's not wise for a beginner to start too small, either. That's because you have the urge to stay at that size of paper and not to give yourself room to grow as an artist. Try doing a painting or two on one-eighth sheet of paper; then quickly move up to quarter sheets and even half sheets.

Paper Pad or Block

Why not just buy a pad or a block of watercolor paper and be done with it? Well, pads and blocks can be more expensive than buying paper in packets of individual sheets. And those individual sheets can be broken down into the size of paper with which you want to work. Blocks and pads limit an artist pretty much to the size the blocks or pads are cut. However, blocks are certainly convenient, especially when painting outside, if only to carry. Blocks also eliminate the need for a backing board.

My advice: Try out a variety of paper, and decide after you paint on it what you feel most comfortable with. Do a similar painting with the same colors on a variety of papers to see how the paint reacts. In other words, play.

FINDING THE RIGHT PAINT

PAINT IS ALSO a matter of personal preference.

The most important thing to keep in mind about watercolor paint is not to consider yourself a student. At least avoid using student-grade paint. This paint is inexpensive but contains less pigment than higher grades of paint. The quality is not as good, and the artwork produced using student-grade paints will also suffer. You want to begin with the confidence that you are better than student-grade paints. If you do, you will be.

Pan & Cake Paints

How do you recognize student-grade paint? Those inexpensive six-color pans of paints generally are student grade. You can buy higher-quality pan-and-cake paints, and they will have the advantage of convenience. You can travel more easily with them. Pan paints also can be stored with ease. They generally come in sets, so you get many different colors. But, it's tough to do a major wash with a small pan of paint, without adding a lot of water.

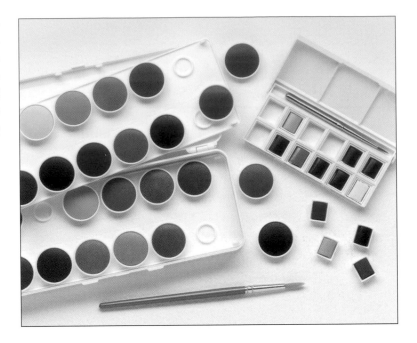

Tube Paints

I recommend that you begin by filling a palette with tube paints, perhaps starting with only the three primary colors and adding a color or two at intervals over time as you become accustomed to the properties of each color. Tube colors usually are of higher quality, and frequently, they're fresher.

I've used many different brands of paint and found Holbein paints work best for me. Holbein does not use ox gall, a wetting agent, in its paint. The colors are noted for their lightfast qualities and physical permanence, both individually and in mixture. There are many qualities I really appreciate about Holbein paints, but the most important reason I use them is because it's easy to read the properties of each color. I find it helpful knowing what a color will do and how it will react in many situations.

BRUSHES

Perhaps the most valuable tools you'll ever own are your brushes. It's extremely important to buy the best from the very beginning. With the right brushes, you'll benefit in your art and learning.

Kolinsky sable brushes are considered the finest brushes on the market. I own many of them. However, quality is not necessarily costly. Personally, I prefer the relatively inexpensive Holbein or Jack Richeson brushes. Unlike some artists who believe that only a Kolinsky sable brush can do the job, I use my Holbein and Jack Richeson brushes almost exclusively. Naturally, we all have different ways of moving and seeing and need to use the tools we feel most comfortable with. Try out several different brushes and make your own choices.

It took me a while to find the right combination that works for me, but in my art, I use a few brushes consistently. These include: 1½-inch flat, 1-inch flat, ¾-inch flat, ½-inch flat, #18 round, and #4 round. The 1½-inch flat brush is great for large washes and glazes.

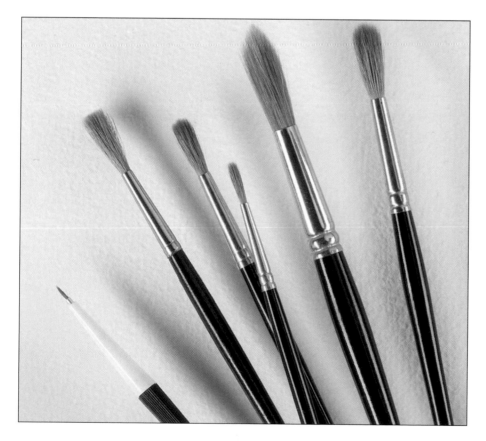

Brush Varieties
Brushes are an artist's most valuable tools. Choose them with care.

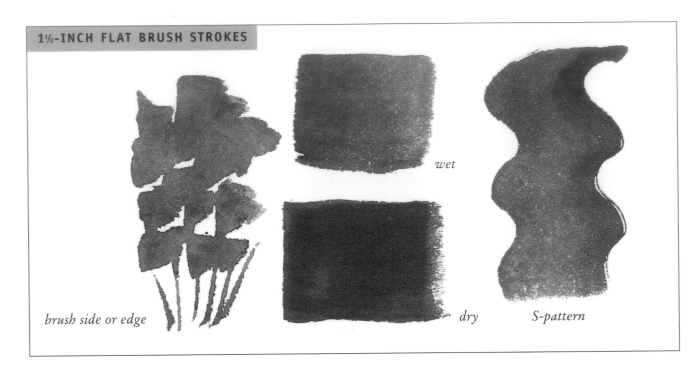

1½-INCH FLAT BRUSH STROKES

brush side or edge

wet

dry *S-pattern*

A 1½-inch brush created the vertical stroke; I used the side and the edge of the brush. The two wide strokes (in the center) were made with a wet brush (top) and dry brush (bottom). Moving the brush in an S-pattern created the stroke on the right.

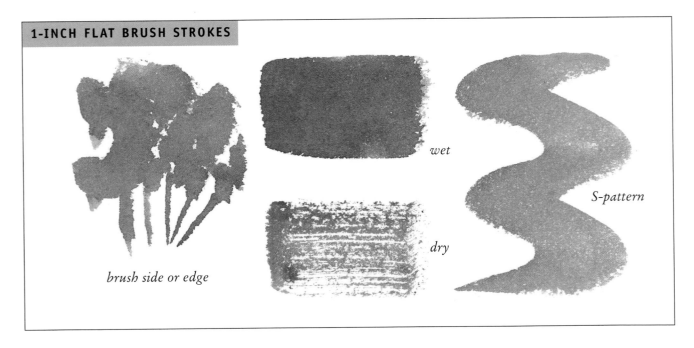

1-INCH FLAT BRUSH STROKES

brush side or edge

wet

dry *S-pattern*

The 1-inch flat brush creates bold strokes; it's also good for washes or glazes. These brushes come in various brands and hair types. Many artists claim Kolinsky sable is the best. Certainly, it is the most expensive. If a brush creates the result you're working for, then that brush is for you, regardless of cost. Here are some strokes you can achieve with a 1-inch flat brush on 140-pound Arches paper.

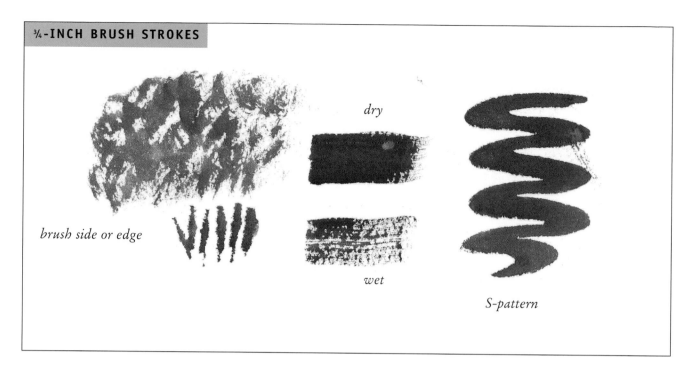

¾-INCH BRUSH STROKES

brush side or edge

dry

wet

S-pattern

These strokes are made with a 1-inch flat brush on 140-pound Arches. The 1-inch flat works in much the same way as the 1-inch, although it's smaller and will make narrower strokes.

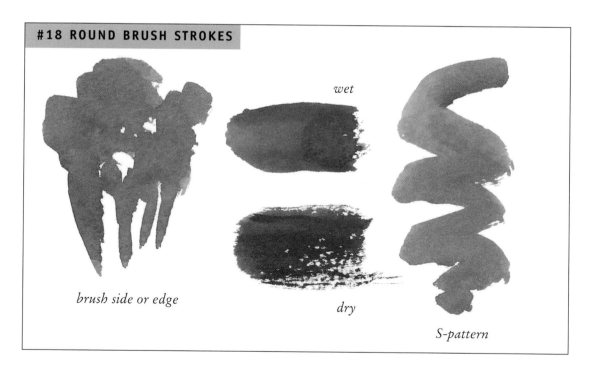

#18 ROUND BRUSH STROKES

wet

brush side or edge

dry

S-pattern

These strokes are made with a #18 round brush on 140-pound Arches paper. It makes much smoother strokes than a flat brush with softer edges. It can be used for larger details.

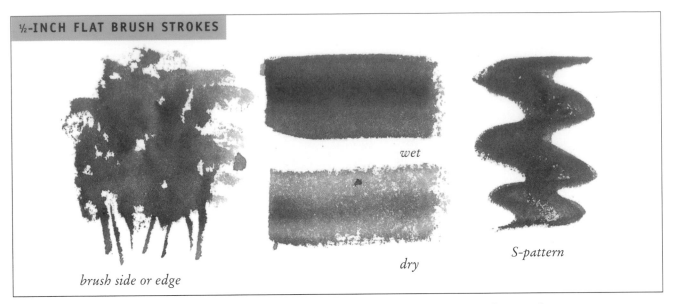

½-INCH FLAT BRUSH STROKES

wet

dry

S-pattern

brush side or edge

Here are examples of strokes made by a ½-inch flat brush on 140-pound Arches paper. The ½-inch flat brush is great for getting into and around edges of shapes in paintings.

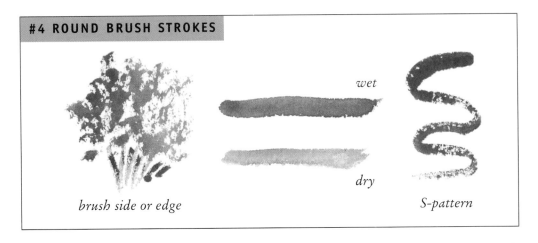

#4 ROUND BRUSH STROKES

wet

dry

S-pattern

brush side or edge

These strokes are made with a #4 round on 140-pound Strathmore Imperial paper. The #4 round is used for fine detail, drawing lines, and lettering.

PALETTES

I USE TWO TYPES of palette, a butcher's tray and the Robert E. Wood palette. However, many useful palettes are available in the market. Find one that suits you.

When I'm throwing paint, I use a butcher's tray. It's also useful for spattering, or any other technique that frees you to mix paint in a less controlled way. The palette's smooth enamel finish allows the

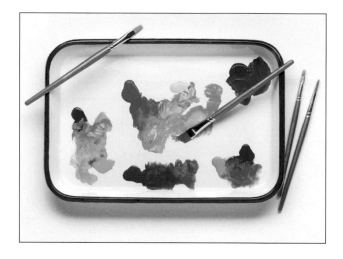

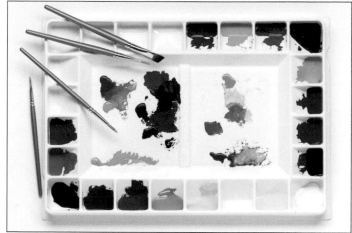

Butcher's Tray or Palette *Robert E. Wood Palette*

paint to run together to form beautiful and surprising colors. Sometimes I transfer luminous patterns from the butcher's tray onto watercolor paper by laying the paper on top of it so that the paper absorbs the pretty colors and patterns. This creates a wonderful background; it also helps you avoid wasting paint.

However, the palette I prefer and use most is the Robert E. Wood, named after the artist who developed it. This very efficient palette has large paint wells and a generous divided mixing space that allows you to mix two different washes at one time.

It allows you more control over your colors. The wells are deep and hold a lot of paint. On the side of the palette, there's space to write the names of colors. You can even store the palette with paint left in the wells. The cover of the palette has four mixing wells, so you can mix as many as six colors at once.

ARTIST'S TIP

Clean brushes on a bar of Ivory soap (or another soap without additives) after each painting session. Rinse thoroughly.

PAINTING SUPPORTS

To PREVENT WATERCOLOR paper from buckling, you'll need to support it. The support needs to be comfortably positioned for your work. Most artists use tape or bulldog clips to attach paper to a wooden board, gator board, or Plexiglas. The support prevents the paper from developing wrinkles when you apply water, and it provides a stable surface for painting. If you then place the board or Plexiglas support on an easel or drafting table, you'll be able to position the paper at an angle that's comfortable for painting.

I use my painting table more often than my easel, although there are many reasons to use an easel. You may like to stand when you paint; I do. I feel in control in this position. I do have a French easel that I use when on location, and that works out well for me due to the flat position the easel allows. Most of the time when I paint *en plein air* (outside), I just prop my board on something and assume a comfortable position.

Whatever painting support you use, it's important to find a home for it. When I began painting, I used the kitchen table. However, for many years I was hesitant to paint because it took so much work to set up. Find a space of your own that you can go to for painting. You don't want to be deterred by the work it would take to get started or by the many possible distractions of life's everyday events. I love the freedom my studio provides. Designate a space for your painting activities that you can use regularly and keep supplies ready.

OTHER SUPPLIES

KEEP A COLOR WHEEL with your painting supplies for reference. You'll find many color wheels on the market. The Color Wheel Company makes a great pocket color guide with an abundance of information that supplements the traditional color wheel.

Use masking fluid to preserve whites. I favor Incredible White Mask liquid frisket. Before I learned how best to apply this mask. I ruined too many brushes to count. Now I use the same brush every time I apply a mask. Lather the brush with an unadultered soap, like Ivory soap. The soap protects the brush from becoming gummy as long as you soap it between each stroke. Then brush the mask on paper area you want to stay white or unpainted until later. Another way to preserve whites is to use masking tape. Of course, you may not be able to achieve some of the same subtlety you can with masking fluid.

Watercolor artists also need drawing materials. Begin each painting with a value sketch and a design sketch. Find a sketchbook you're comfortable with and some drawing pencils. I favor using a #2B or #3B pencil for sketching because these pencils contain a soft lead that, when combined with a soft touch, will leave a light impression. A soft gum eraser or a kneaded eraser will not damage the paper surface of sketchbook or watercolor paper.

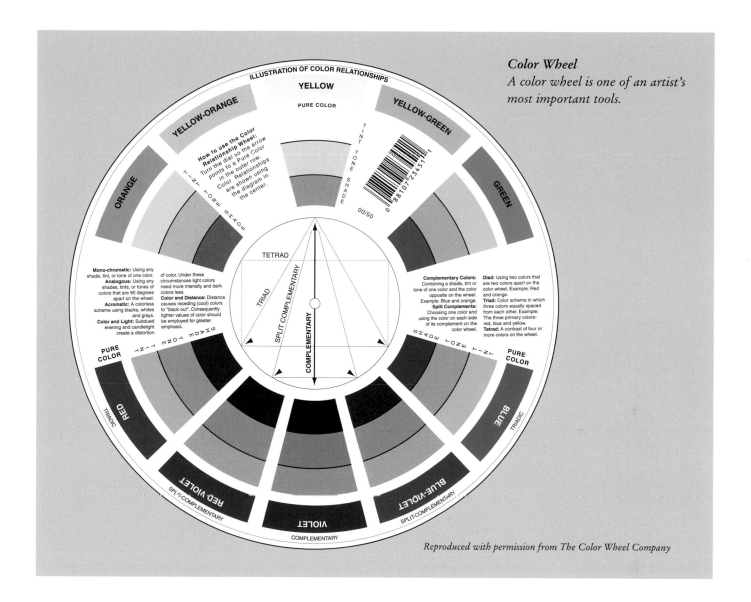

Color Wheel
A color wheel is one of an artist's most important tools.

Reproduced with permission from The Color Wheel Company

Household Tools

A surprising number of household items can do double duty as artist's tools. Spatter or scrub out paint with old toothbrushes. Move paint around the painting with a spray bottle or atomizer filled with water or alcohol. Clean brushes or lift paint to create shapes, like clouds, with tissue and paper towels. Create texture on a wet paint surface with plastic wrap and wax paper. Shift paint around with a razor blade. Just use your imagination to discover the variety of objects around the house that you'll want to add to your painter's toolbox.

Shaping
Composition & Design

WHAT IS DESIGN?

THE WATERCOLOR ARTIST creates a three-dimensional illusion on a two-dimensional piece of paper. It is just so long and so wide. Within this area the artist creates a feeling of distance as infinite as the sky. At the same time, some things must appear realistically close— so near that the viewer believes he can reach out and feel both the roughness of a rock and the softness of a flower petal.

Composition refers to the total content of a work of art, and *design* refers to the arrangement of elements of the work.

ABOUT SPACE

SPACE EXISTS IN a painting only as an illusion, but it gives life to the visual design. Flowers, lighthouses, and other forms have substance, so the space they occupy in the picture is sometimes known as occupied space. The area around them is unoccupied space, or negative space. Hold your hand at arm's length and extend your fingers. The fingers represent occupied space (positive space). The area between the fingers is unoccupied space (negative space).

Even if you stretched your fingers out so that the space between them seems almost equal, there's still a difference. Note the space between the thumb and forefinger and between the little finger and the ring finger. Now, move two of the fingers closer together. Notice how the change in the space changes the entire design.

Because the only whites we have in watercolor are the paper and the water, we more often paint in the negative or unoccupied space behind a form that must be light or dark to show its shape.

Lilacs
Marcia Moses, 22 × 30 inches
(pp. 24–25)

To understand negative space, think about space that an object occupies. Look behind it to see what does not exist; this is negative space. Negative space brings to life the object that you're trying to make stand out. Understanding positive and negative space is one of the most important concepts in design. It applies to all art media, including watercolor.

LIGHT & DARK COLORS

LIGHT NEXT TO dark creates tension. Dark will push objects back. Light will make objects come forward.

These are the facts of life in art. They're not my ideas, but what you or I choose to do with them are our own personal interpretation(s). The masters gave us so many tools and concepts that being an artist is easier today than in past centuries. These tools and concepts help our own personal creativity to soar.

If you apply the seven basic elements of design, you'll be successful. It's important to allow yourself to make mistakes, forgive yourself, and move on. This is all part of the learning process. We learn by taking artistic and intellectual risks.

ARTIST'S TIP

To create unity, use at least three design elements in each painting.

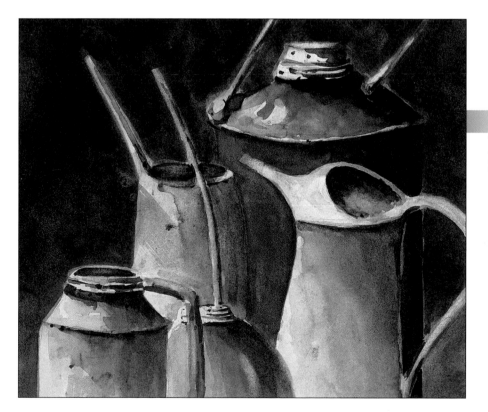

Yesterday
Marcia Moses and
Wanda Montgomery
16×20 inches

The Seven Elements of Design

Design exists in everything around us, from the simplest flower to the complex human structure. To design is to have purpose.

Designing in art means deliberate planning and arranging elements in a way that creates a unified effect. When used together, all design elements help create unity in a painting. The seven elements of design— shape, size, line, texture, value, color, and form— are the building blocks of an artwork.

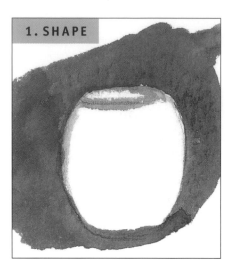

Any object with height and width has a shape. A positive shape automatically creates a negative shape.

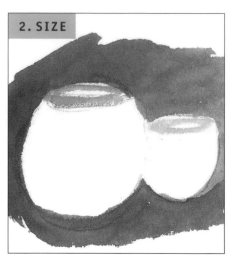

Size is very simply the relationship of the area occupied by one shape to that area occupied by another shape.

Watercolors are basically pigments ground in water and bound with gum. Color is what that pigment is: red, yellow, blue, orange, green, violet, etc.

Form, the surface characteristics of an object, describes an object's three-dimensional qualities, such as its roundness or volume. The object's shape suggests the form, but its true nature is revealed through the variations of light and shadow. Sometimes direction replaces form as a design element.

DESIGN ELEMENTS COMBINED

When you combine all seven elements, the painting can become busy. It's better to use just three or four of these elements, like the painting on page 29 (bottom). This painting combines the elements shape, color, form, and size.

3. LINE

There are two ways to describe line: the marks made with a pen, pencil, or brush, or the edge created when two lines meet.

4. TEXTURE

Texture is the surface condition of a shape: rough or smooth with a hard or soft edge. Texture can be physical and tactile, or it can be merely a visual illusion.

5. VALUE

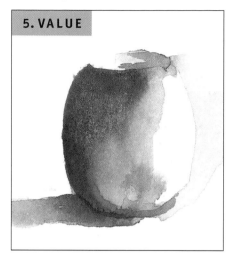

The value of a hue is determined by its intensity. A value range from 0 to 10 has 10 void of color and 0 as the full color. (Some value scales may reverse that and give 10 as full color and 0 as void of color.)

COMBINED ELEMENTS

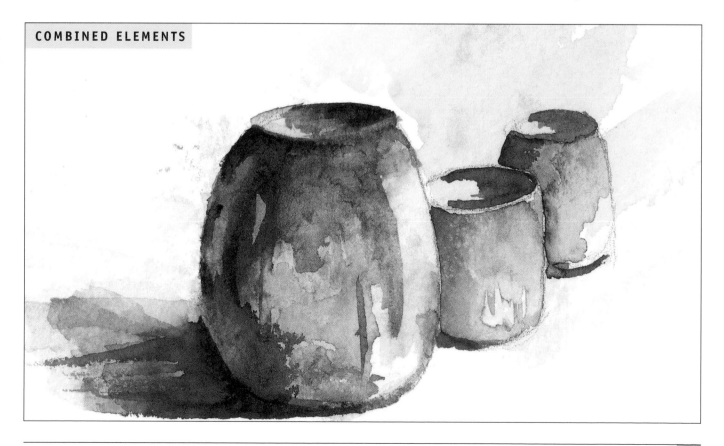

Unity Placement of design elements in relation to one another to create a psychologically and aesthetically pleasing whole. All design elements in a painting play off or interact with one another.

Harmony The visually satisfying effect of combining similar related design elements or objects in a painting, such as colors adjacent to each other on the color wheel, similar shapes or textures.

Balance Avoiding a lopsided appearance in a painting; creating equilibrium. Directional lines at different angles, distribution and intensity of color, and proportionate areas allotted to significant and secondary parts of the composition contribute to the painting's balance.

Rhythm In a work of art, variety and repetition of design elements create rhythm.

Contrast The juxtaposition of dissimilar elements, such as color, tone, or emotion, in a work of art. The artist can play light against dark, soft against hard, or warm against cool. Locate the major contrast in a painting at the center of interest.

Dominance Resolving conflicting ideas by making one idea or element, such as color or direction, more important than other competing ones. Usually, one area painting is dominant. The painting's center of interest or focal point dominates the rest of the painting.

Gradation This creates a three-dimensional effect with different tones or grades of color from dark to light or warm to cool. The decreasing or increasing strength of shades, tints, or values of color. Gradation helps produce interest, define areas in a painting, and provide smooth transitions.

ARTIST'S TIP

If you feel lost in a painting, that usually means there's a problem with design.

DISCOVERING HOT SPOTS

THE ELEMENTS AND principles of design used together in an orderly fashion make up the composition of a painting. Using the simple grid will allow you to create an organized work of art.

Here's a procedure for creating a simple grid: **(1)** In every rectangle there are two squares. The way to find the two squares is to measure the shortest side of the paper and then measure in that

distance from the edge of the long side. For example, if you are working on an 11×15-inch piece of paper, your shortest side is 11 inches. So 11 inches would be the distance you would measure into the rectangle from the corner of its long side. Draw a line from the top to the bottom of the paper. Measure the same distance from the other side, and draw another vertical line. **(2)** There also are two diagonals in every rectangle. Draw a line from the top right to the bottom left corner, and another from the top left to bottom right corner. These diagonal lines will meet in the middle. This establishes the center of the paper. **(3)** Then draw two horizontal lines that intersect both the vertical and diagonal lines. **(4)** Find the resulting hot spots, where you need to place the painting's center of interest.

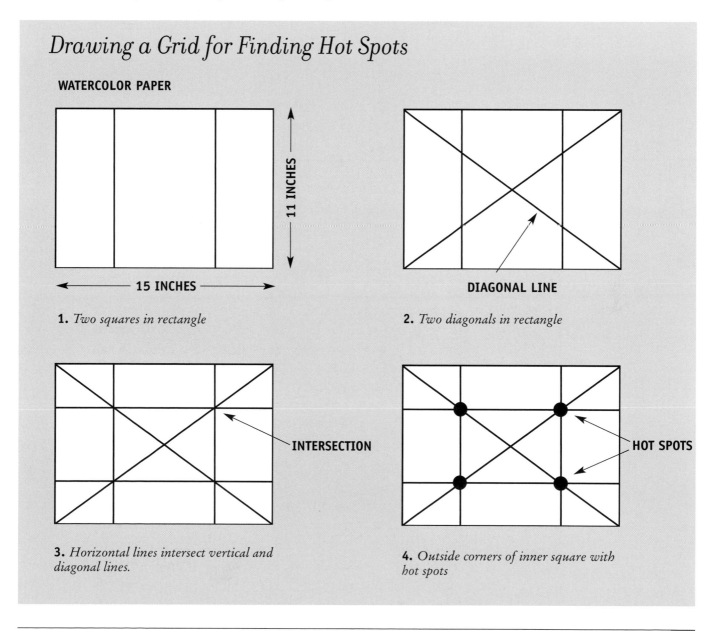

Drawing a Grid for Finding Hot Spots

WATERCOLOR PAPER

11 INCHES

15 INCHES

1. *Two squares in rectangle*

DIAGONAL LINE

2. *Two diagonals in rectangle*

INTERSECTION

3. *Horizontal lines intersect vertical and diagonal lines.*

HOT SPOTS

4. *Outside corners of inner square with hot spots*

The viewer's eye naturally goes to the hot spots, the points where the vertical and diagonal lines meet at the corners of an inner square. (Painters and photographers also call this the "rule of thirds.") If an artist places important shapes or the center of interest in any of these four areas, the viewer's eyes will be led into the painting at the spot the artist desires. It is most common to bring a viewer into a painting from the lower left corner, leading him up the diagonal to the hot spot, then allowing less important shapes to guide him through the rest of the work of art.

If you have your center of interest in the center of the paper, your viewer is going to be led directly to that area and stop with nowhere else to go. Look for the hot spots, and use them to improve your *design,* the arrangement of elements in your artwork.

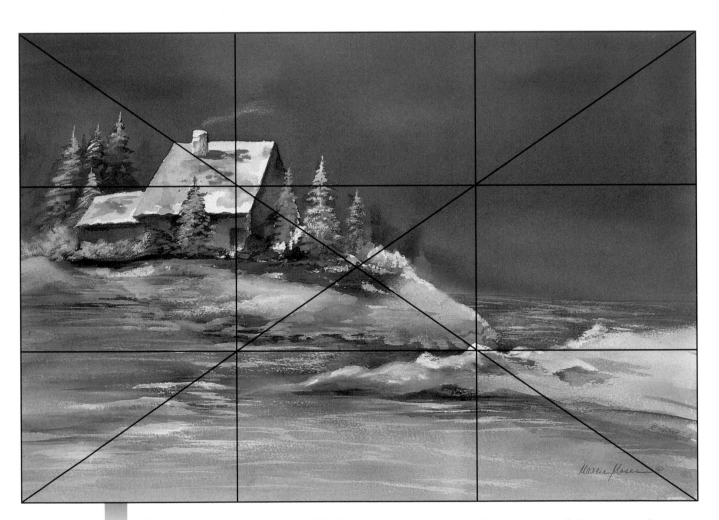

Winter Solstice
Marcia Moses, 11 × 14 inches

The house in this watercolor is located in one of the painting's hot spots.

LEARNING TO SEE

IN ORDER TO increase your visual awareness, you need to learn how to see as an artist. How do we see things differently than we do now? We do that by becoming more aware of what it is that we're looking at.

To do that, first look at an object. Let's try a tree. Now squint your eyes. Squinting your eyes creates a frame that helps you more clearly see the darks and the lights of objects.

Now look behind the lighter objects. What do you see? Dark shapes? This is called negative space.

Squint again. What else do you see? Do you see some shapes that are lighter than others or darker than others? Lighter objects will appear to come forward and darker objects will recede.

The difference between the lightest and darkest of the objects is the difference in what is called *value.*

However, there are more values than just light and dark. The shadowed side of the tree is going to be darker than the lighted side of the tree, but not as dark as the tree's background. This in-between dark and light is called a middle value.

Begin to look at everything as values: darks, lights, and middle values.

It's amazing all that you can see when you begin to see as an artist does.

"Your vision will become clear Only when you look into your own heart.
He who looks outside dreams.
He who looks inside Awakes."

—MARC CHAGALL (1887–1985)

Tree
Marcia Moses, 4 × 5 inches

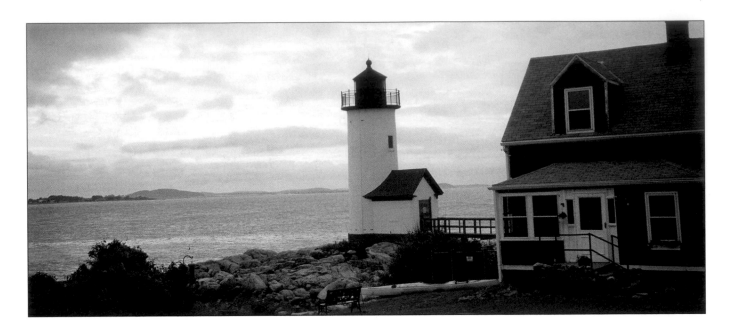

Photo of Annasquam Light in Gloucester, Massachusetts

Seize the Moment

Along with your sketchbook, make a camera your close companion. We stumble upon beauty when we least expect it. We never know when a sunset will offer lively colors that hit water so perfectly they almost seem to dance. If you have your camera, you can capture that image in a picture, and use that photo at a later date to reproduce the image on paper or canvas.

Being an artist today is so much easier than it was in the past. We are so fortunate to be able to capture moments of beauty on film. Claude Monet painted water lilies many times to reproduce in a painting what he saw as the perfect light. Imagine what a visual memory he must have had. The camera can remember what we forget.

I always carry my camera when I am painting *en plein air.* The light can change so rapidly that the very essence of what I am looking at can disappear in an instant. Seize the moment with a camera.

DRAWING

BEING ABLE TO draw, not just to paint, is important to an artist.

If you sketch your subject before painting it, you'll not only create an outline for your artwork, but you'll also get to know each object inside and out. Whenever you draw an object, say for example

an apple, you not only have to draw the front part of the apple. You must create the illusion that the apple has a backside without actually showing that side of it. Viewers must see the apple's curvature and believe that it isn't flat. Drawing each object will help you give them three dimensions.

When you begin drawing an object, think of it as a shape and forget about detail. When you're painting a lighthouse, think of the bottom of the lighthouse as a cylinder, the top as an ellipse, and the roof as a triangle. If you simplify the object into such basic shapes, it will be easier to draw.

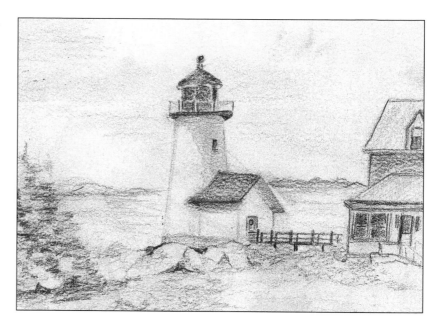

Sketch of Annasquam Light

Once you've established all the basic shapes, you'll have what is called a *value sketch*. Determine what are the lightest parts of the object and what are its darkest darks.

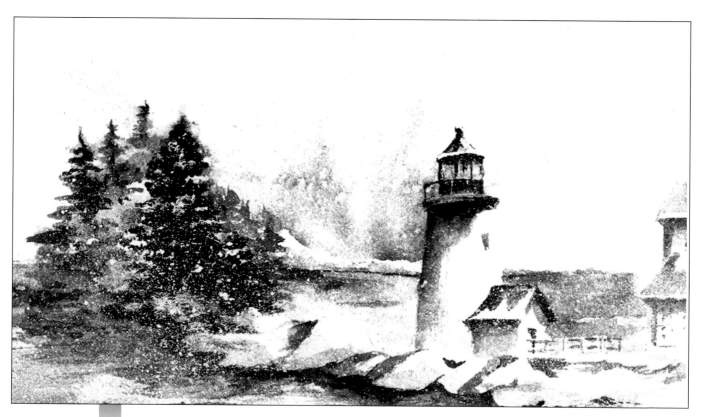

Annasquam Light
Marcia Moses, 11 × 14 inches

Squint to See

This little exercise will help you draw what you see with more depth, shape, and accuracy, thereby improving the illusion.

1. Look at a tree.
2. Squint your eyes to create a frame for the image.
3. Look at the values in the image and behind the image; see the darks and the lights.
4. What shapes do you see within the tree?
5. What shapes make up the negative space behind the tree?
6. Now begin to draw the tree's overall shape (the positive space). When your drawing takes on the shape, texture, and depth of what you're seeing, put down your pencil and pick up your brush.

Photo of Lanterns

Mystic Lanterns
Marcia Moses, 22 × 30 inches

READ ABOUT IT

A number of excellent books deal with drawing and how to reproduce what you see. Here are my favorites:

Stan Smith, *Step-by-Step Drawing* (Sterling, 1994)

Michael J. Gelb, *How to Think Like Leonardo da Vinci* (Delacorte Press, 1998)

Betty Edwards, *Drawing on the Right Side of Your Brain* (Tarcher/Putnam, 1979)

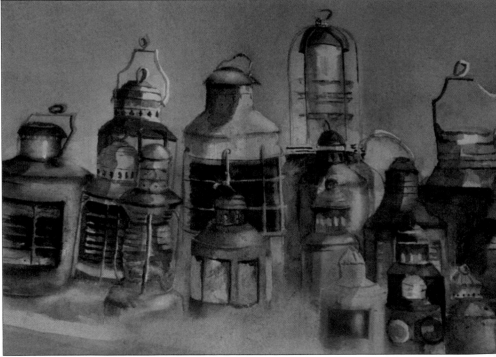

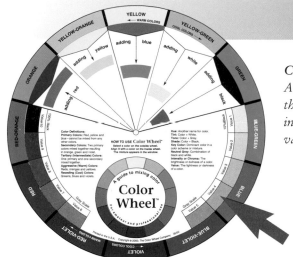

Color Wheel with Gray Scale
A pocket color wheel, like that shown here, usually includes a gray scale with values ranging from 1 to 10.

What Is Value?

Value is the lightness or darkness of a color. I have a value scale that measures values from 1 to 10. On this scale, 10 is the lightest. (If you wish, you could have 10 as the darkest and 1 as the lightest.) Here we will be working with the lightest or white of your paper as 10 and the darkest value as 1.

Consider using a common gray scale. Practice using this scale to produce sketches that show varying shapes. But use only two, three, or four values. As you add more values, notice how your drawings take on more depth. However, adding too many values can make a drawing too busy, and the artist could get confused. Less is more.

To make the gray scale work for you, let's consider an apple. Sketch and draw an apple to produce the shape and give the shape dimension. Here is a five-value sketch that shows its darks and lights.

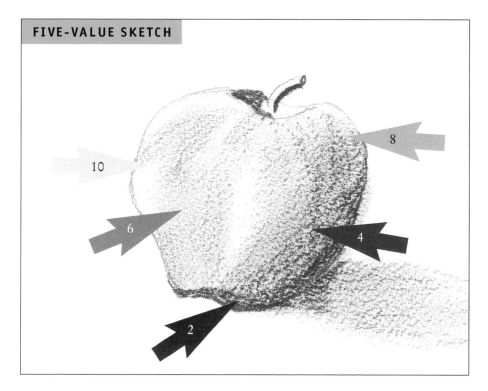

FIVE-VALUE SKETCH

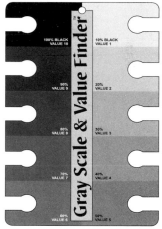

Gray Scale
This gray scale has ten gradated steps from white (10) to black (0). Compare this scale to your color to determine its specific intensity. Using colors of the same value provide the best visual results.

Shaping Composition & Design **37**

SIMPLIFYING THE VALUE SCALE

I'VE RECENTLY begun to use a simplified value scale. This simplified scale makes understanding and using values less complicated.

When a painting has too many colors, it becomes very confusing for the viewer. The use of too many values has the same effect. In order to give a painting a clean appearance, we can reduce the ten values to three or five.

When we paint, we are telling a story. If that story has too much information, the "reader" will lose interest. By simplifying the painting process, we hold the viewer's interest. Again, less is more.

Simplified Value Scale

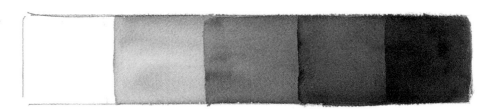

Creating a Simplified Value Scale

To create a simplified value scale, begin by mixing a large amount of cobalt blue on a palette in a ratio of one part water to five parts paint.

Use a small piece of watercolor paper 3×12 inches and draw a box on it that's 2×10 inches. Now divide this into five 2-inch spaces. These boxes will contain your five values.

Gradated Washes

FIRST WASH
TWO-VALUE SCALE

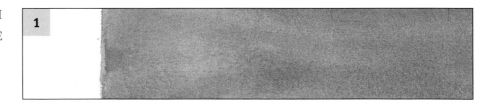

Begin by skipping the first box. This will be your white value. Then paint a wash over the next four boxes. Let the paint dry. Or dry it with a hair dryer; it's faster. With the paper's white and the first wash, you have a two value scale.

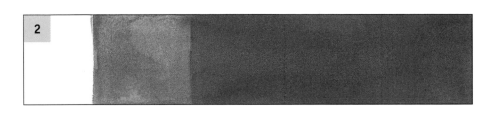

TWO WASHES
THREE-VALUE SCALE

Now paint a second wash of the same paint mixture, but begin at the third box, covering the three boxes painted with the first wash. Dry this second wash.

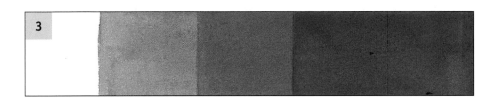

THREE WASHES
FOUR-VALUE SCALE

Put a third layer of paint on the fifth and sixth boxes.

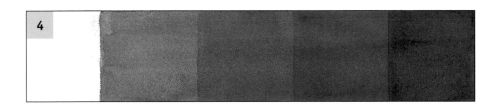

FOUR WASHES
FIVE-VALUE SCALE

Cover the fifth box with a fourth, final wash.

The result of the four washes is that each box has a different value. Now you have a simplified five-value scale that you can use for any painting. You could simplify this scale even further by reducing it to three values, but the five-value scale seems to work most effectively.

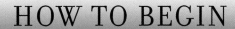

ARTIST'S TIP

A value scale is a very useful tool. Keep one handy whenever you paint.

HOW TO BEGIN

WHEN BEGINNING a painting, it's helpful to follow a routine to organize your thoughts. First choose your subject. Then figure out what shapes you want to use. Sketch the shapes. Decide where the lightest and darkest shapes are on your subject, breaking this down into five values.

Applying Values

Here's how to create a painted value sketch by adding values one by one.

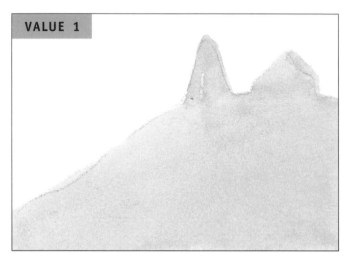

VALUE 1

First value with light wash.
In this painting the first value is applied with a light wash over the lighthouse and shapes of rocks. There are three basic shapes in the composition. The sky and rocks are the largest shape, and the lighthouse is the smallest shape.

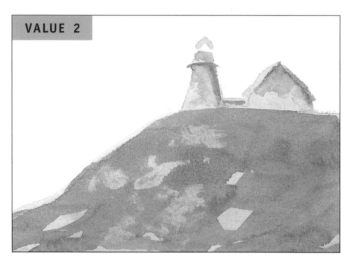

VALUE 2

Value change with paint on rocks.
Next, apply the paint to the large rocks' shape. You can now see the value change.

VALUE 3

Three established values.

VALUE 4

Detail added to create value sketch with paint.
Begin to put another layer of the same color on top of the largest shape, the rocks. Do some negative painting and form some smaller shapes inside the larger one. (See negative space on p.26 and negative painting on p.86.)

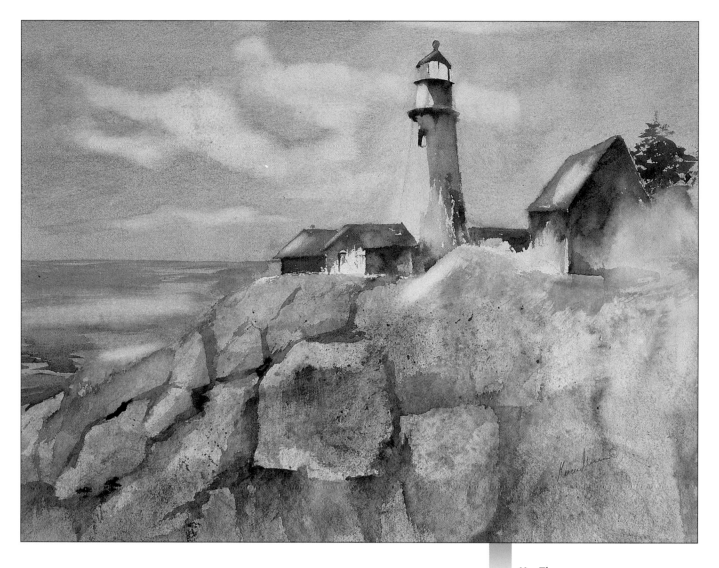

THE FINISHED PAINTING

Up There
Marcia Moses, 22 × 30 inches

I began my painting with the value sketch and then converted the value into color.

I used an aureolin yellow wash over the lighthouse and rock shape. Then while the painting still was wet, I dropped in some rose madder and let it spread on the rocks. I put a wash of ultramarine blue over the sky area. Then I dried everything and darkened the water shape with another ultramarine wash. With a third wash on the water, I skipped over a few lighter areas to show the sky's reflections in the water. After a little detailing, I was done.

Working with Color

T HE STUDY OF COLOR is fascinating and vast, and some books deal with color exclusively. It's good for beginners to learn standard color terminology, color theory, and principles of color mixing. We'll simply cover the basics here. Many artists have developed a fine sense of color and how to use it. However, not all artists are good colorists. If you're keen on what color can do, study it more.

THE PROPERTIES OF COLOR

HUE *an object's "local" or true color.*

The color you perceive when you look closely at an object is its *local color.* For example, green is the local color of a blade of grass in spring.

But, a green can appear quite bluish when seen from a long distance because of atmospheric effects. This is called *atmospheric color.*

Local color can also be affected by colors reflected from surrounding objects. A green apple in your still life may have hints of red in it from a neighboring red jug. The green blade of grass may have a blue-green tint as it catches the blue of the sky.

VALUE *the degree of lightness or darkness of a particular hue.*

I may look at a piece of wood and call it brown, but there are shadows on parts of the wood that make those areas darker brown. Those two shades are the same color, but different values.

Local Color of Grass

INTENSITY *a color's strength or weakness, brilliance or dullness.*

A barn can be red. But the sun shining on a part of the barn can make that area more brilliant red. And, in the same respect, a shadow on another part of the same barn can create a dull red in that area.

BASIC COLOR THEORY

A COLOR WHEEL shows us the twelve basic colors, which derive from (and include) the three primary colors. The three primary colors can be mixed to obtain the three secondary colors, which can be mixed with the primary colors to create the six tertiary colors.

Primary colors are red, yellow, and blue. You cannot create these colors by mixing other colors.

Secondary colors are orange, green, and violet. To create these colors, mix two adjacent primary colors. For example, red plus yellow makes orange, blue plus yellow makes green, and red plus blue makes violet.

Tertiary colors are yellow-orange, red-orange, yellow-green, blue-green, blue-violet, and red-violet. To produce these colors, mix a primary color with a secondary color.

Complementary colors lie directly opposite each other on the color wheel. For example, red is the complement of green, and orange is the complement of blue. If you combine a pair of complements, you can neutralize the colors and produce some very nice grays. It is often better to allow one of the colors to slightly dominate the mix to ensure that the gray is not too dull and lifeless.

Primary Colors

Secondary Colors

Transparent & Opaque Paints

If a paint color is transparent, you can see through it; it's like plastic wrap. If opaque, you can't see through the color; it's more like a brown paper bag.

Telling the Difference

Knowing when a paint color is transparent or opaque is extremely important, especially if you are glazing. You glaze one color over another in order to make the color look luminous. In order to get that luminosity in a color, you need to use transparent colors so that the other colors will show through.

For example, if you lay down a transparent yellow and dry it, then add a layer of transparent red on top of the yellow, you'll be able to see the yellow through the red.

Here's a simple test to find out whether a color is transparent or opaque. Draw a line with a black permanent felt-tip marker. Now paint over the black line. If the line easily shows through, the color is transparent. If it doesn't, the color is opaque.

Opaque Colors

CADMIUM YELLOW-ORANGE

YELLOW OCHRE

PERMANENT YELLOW-ORANGE

CERULEAN BLUE (SEMI-TRANSPARENT)

LILAC

CADMIUM RED DEEP

CADMIUM RED-ORANGE

VERMILION

SHELL PINK

Transparent Colors

BURNT UMBER

GAMBOGE NOVA

AUREOLIN YELLOW

CADMIUM YELLOW LIGHT

HOOKER'S GREEN

ULTRAMARINE DEEP

ROYAL BLUE

COBALT BLUE

MARINE BLUE

PERMANENT ALIZARIN

LIGHT RED

OPERA

ROSE MADDER

PALE TINTS

Don't be tempted to use white paint to achieve pale colors. In pure watercolor work, pale tints of any color are created with the help of the white of the paper and lots of water. For example, if you want a very pale blue, dilute one of your blues with plenty of water, and test the mix on a scrap of paper until you get just the pale tint you're seeking.

THE LIMITED PALETTE

The advantage of using a limited palette is that it provides unity. With just the three primary colors—a red, a yellow, and a blue—you can produce a full range of secondary and tertiary colors. Your painting will naturally have a good sense of unity because all the colors you mix will contain some or all of those primary colors.

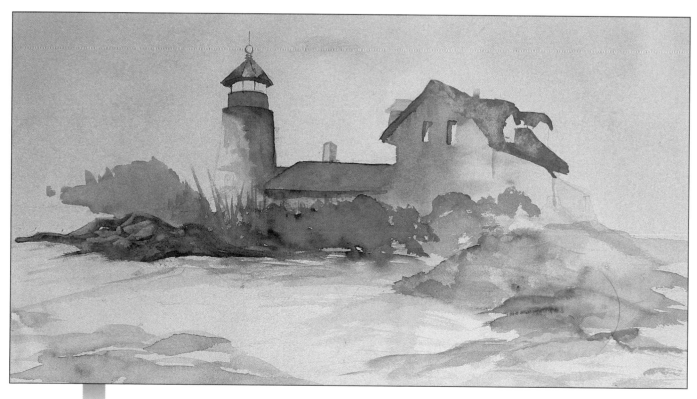

Guiding Light
Marcia Moses, 22×30 inches

Using a limited palette to create unity.

Many beautiful paintings have been created with limited palettes. You can create a high-key painting, such as "Guiding Light," that exhibits light and airy colors, by using just diluted tints of aureolin yellow, rose madder, and cobalt blue. Strong shades of dark colors, however, also are possible with this triad, if you use darker values. Mixing the colors with less water will create a low-key and rather heavy and moody painting, such as "Southwestern Vessels."

Less water creates a heavy and moody look.

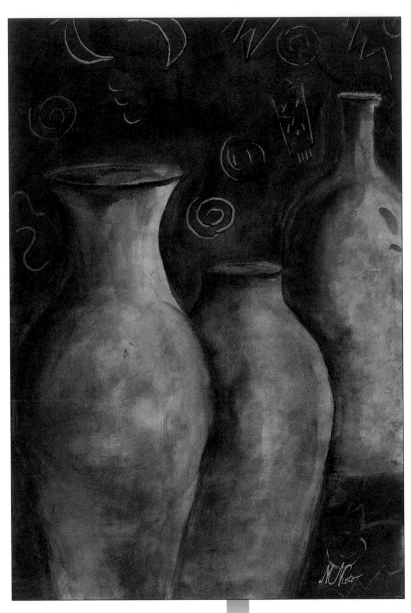

Southwestern Vessels
Mary Nieto, 15 × 22 inches

COLOR TEMPERATURE

TO UNDERSTAND COLOR temperature, think of the dashboard control of a car's heater and air conditioner. Push the lever toward red to get heat. Push it toward blue to get cool air.

Actually, red is not the warmest color, and blue is not the coolest color. Viewed alone, the warmest is yellow and the coolest is black. Their relationship with each other is more important to the artist than their position on a color wheel.

The temperature of a color determines how it relates to other colors in a painting. For example, if a warm color, such as red, is placed beside a cool color, such as blue, the warm color seems to come forward and the cool color seems to recede. This is important when establishing an object's three-dimensional form or when creating the illusion of distance.

I've constructed a warm-to-cool color chart to illustrate the relative temperature of various colors. I've placed warm colors on top and cool colors on the bottom. As you'll see, some colors cannot be

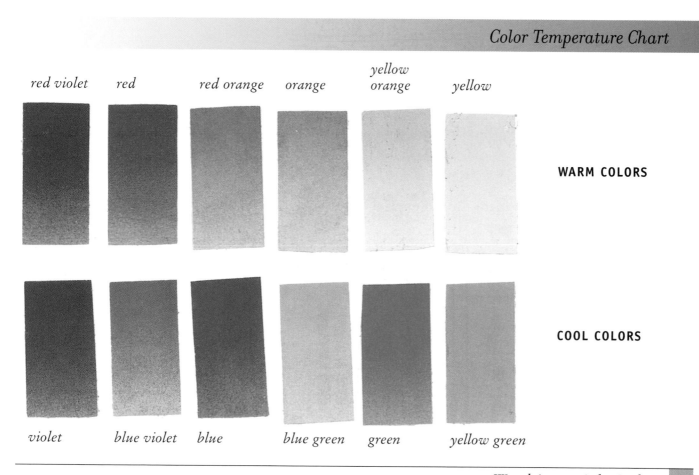

Color Temperature Chart

red violet red red orange orange *yellow orange* *yellow*

WARM COLORS

COOL COLORS

violet *blue violet* *blue* *blue green* *green* *yellow green*

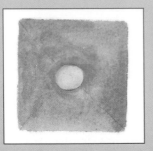

*Light warm recedes on
medium warm background.*

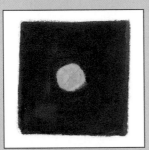

*Light warm comes forward
on medium cool background.*

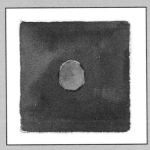

*Light cool comes forward
on warm background.*

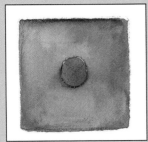

*Light cool receds on
medium cool background.*

categorized as completely warm or cool. To create this chart, I cut a color wheel in half and flattened it out. As the colors are found on a wheel, violet is beside red violet and yellow is beside yellow-green. Violet, red-violet, and yellow-green all have qualities of both warm and cool colors.

Temperature is relative to its surroundings. In other words, warm colors recede on a warm background, and cool colors come forward on a cool background. It sounds confusing, but you can do a simple test with the colors you're using.

To demonstrate, I've created both warm and cool color background boxes. A yellow circle in the middle of a warm yellow background recedes, but a yellow dot on a cool violet background appears to come forward. A light cool blue placed on a light warm red appears to come forward, but the light cool blue placed on a medium cool blue-green will appear to recede.

Push-Pull of Warm & Cool Colors

This interaction of cool and warm colors in art is called the "push-pull" concept. If you have a cool dark color and you put a warm light color beside it, the dark color will push back. If you then place another warm color on the other side of the dark color, the light color will pull forward. This creates a three-dimensional quality in a painting, or movement.

For example, using colors that push and pull can move the eye toward and around an object, such as a lighthouse, in a painting. The cylinder shape of a lighthouse will remain flat until you use lights and darks around it to create dimension. In "Dyce Island Light" (p. 51), in order to make the lighthouse look believable, I added cool dark shapes—shadows and trees—to allow the eye to "see" that it was a cylinder. The darks pulled the eye toward the back of the lighthouse. Additional darks defined the shape of the shelf at the base of the light atop the lighthouse.

I added the dark color on the roof of an adjacent building to push the house behind it into the background.

The series of warm and cool colors to the right in the foreground of the painting helps draw the viewer's eye back toward the structures that are bigger and more important shapes. The narrower series of warm and cool colors to the left in the foreground draws the eye up the diagonal, specifically to the lighthouse shape, the painting's center of interest.

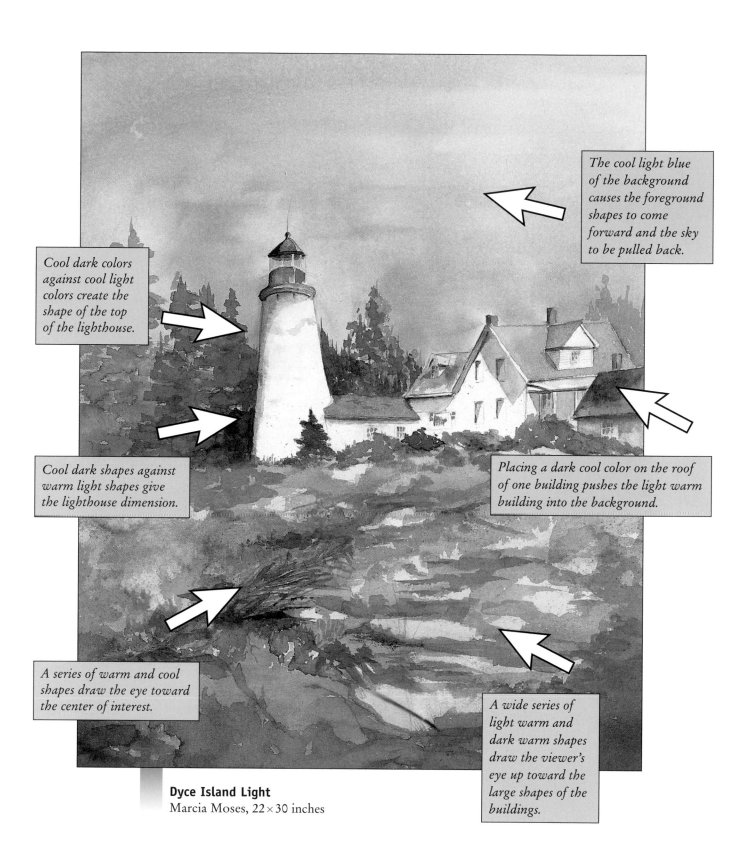

The cool light blue of the background causes the foreground shapes to come forward and the sky to be pulled back.

Cool dark colors against cool light colors create the shape of the top of the lighthouse.

Cool dark shapes against warm light shapes give the lighthouse dimension.

Placing a dark cool color on the roof of one building pushes the light warm building into the background.

A series of warm and cool shapes draw the eye toward the center of interest.

A wide series of light warm and dark warm shapes draw the viewer's eye up toward the large shapes of the buildings.

Dyce Island Light
Marcia Moses, 22 × 30 inches

PRIMARIES & THEIR COMPLEMENTS

FINDING THE COMPLEMENT of a color is quite simple. On a standard color wheel, a primary color is located directly across from its complement. All colors have a complementary color, and knowing the complement of a color can be very important. For example, if you question whether something is missing from your painting, using a complementary color beside the original color to bring attention to that area of the painting.

You can also "gray" an area by placing a wash of the complement on top of a color. Or you can paint using only complements. This will create a painting with both warm and cool areas, with lots of the push-pull effect that creates movement.

Try making a painting using only complementary colors. This is a great way to learn how to use the color wheel.

Primary blue with orange complement

Primary red with green complement

Primary yellow with violet complement

MIXING COLORS

MANY COMBINATIONS of colors are possible when using watercolor. Some results can be good, but others can be artistic disasters. Being aware of a color's properties will give you the advantage of knowing what will happen if you mix it with two, three, or more colors. When you gain this knowledge, your painting will greatly improve.

Every color has a "bias" toward another color; we can call this an undertone. As we discussed when talking about warm and cool colors, a warm color, such as alizarin crimson, has a bias toward blue, or simply a blue undertone, that gives it cool tendencies. This can be a positive feature in your painting if the alizarin is mixed with a blue that also is cool, such as cobalt, if the goal is to create violet. If the blue maintains a yellow undertone, such as cerulean blue, you would create a grayed or muddy violet.

ARTIST'S TIP

To make an object stand out, use its complementary color next to it.

Muddiness

Muddiness is caused by the influence of all three primary colors on the mixture. Any time you mix all three primaries in equal parts, unless they all have the same undertone (say, yellow), you'll get muddiness. If you mixed alizarin crimson with cerulean blue that has a yellow undertone, you'd get a muddy violet.

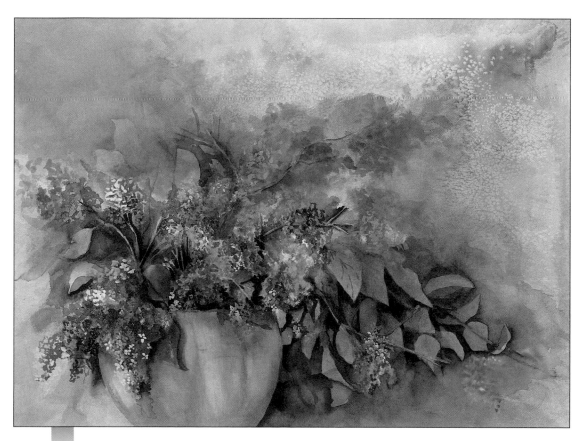

Fresh Lilacs
Marcia Moses, 22 × 30 inches

Color Undertone or Bias

The example to the right is a mixture of aureolin yellow, alizarin crimson, and cobalt blue. You have a yellow that's blue-biased, a red that's blue-biased, and a blue that's red-biased.

We usually say the yellow a blue undertone, the red has a blue undertone, and the blue a red undertone. The result is violet.

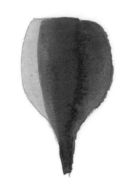

Here are some examples of frequently used colors and their undertones or biases:

- **ALIZARIN CRIMSON (RED)**—*blue undertone*
- **COBALT BLUE**—*red undertone*
- **CERULEAN BLUE**—*yellow undertone*
- **ROSE MADDER (RED)**—*blue undertone*
- **AUREOLIN YELLOW**—*blue undertone*
- **ULTRAMARINE BLUE**—*red undertone*
- **CADMIUM YELLOW**—*red undertone*
- **CADMIUM RED**—*yellow undertone*
- **LEMON YELLOW**—*blue undertone*

rose madder + cobalt blue → violet

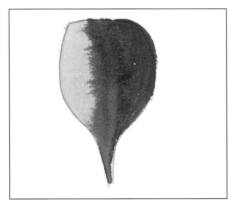

aureolin + ultramarine blue → green

alizarin crimson + ultramarine blue → violet

aureolin + cobalt blue → green

aureolin + rose madder + cobalt blue → green

cadmium yellow light + marine blue → green

Here are some fun mixtures of colors that work well together. Try mixing your own colors to find out what you get. Make note cards with the mixtures on them for future reference. Here we use various combinations of easily available watercolors, rose madder, aureolin, cobalt blue, cadmium yellow light, marine blue, and alizarin crimson.

rose madder + aureolin → orange

aureolin + cobalt blue → green

cadmium yellow light + marine blue → dark green

rose madder + aureolin + cobalt blue → blue-green

aureolin + cobalt blue + alizarin crimson → gray-green

cadmium yellow light + marine blue + rose madder → dark gray-green

COLOR SCHEMES

EVERY COMPOSITION SHOULD have a color scheme so that you'll have harmony in your painting. These are several different color schemes—triad, complementary, analogous, and monochromatic, among others.

A **triad color scheme** allows one choice from each of the red, yellow, and blue color families.

A **complementary color scheme** uses two colors opposite each other on the color wheel.

An **analogous color scheme** uses any three adjacent primary, secondary, or tertiary colors.

A **monochromatic color scheme** uses one color in various values.

Triad Scheme

Complementary Scheme

Analogous Scheme

Monochromatic Scheme

MIXING GRAYS

TO ADD CONTRAST to a composition, you need to have some darker values. So, in order to create a darker value than you can get from a single color, you need to mix two colors and often to add a third color. This will darken, or gray, the color scheme in that area.

You can mix grays in triad, complementary, analogous, mono-chromatic, and split-complementary color schemes like this:

Triad Mix semi-neutrals, or grays, by using two of the colors in the triad with the third added to gray the two colors.

Complementary These colors automatically gray each other when mixed.

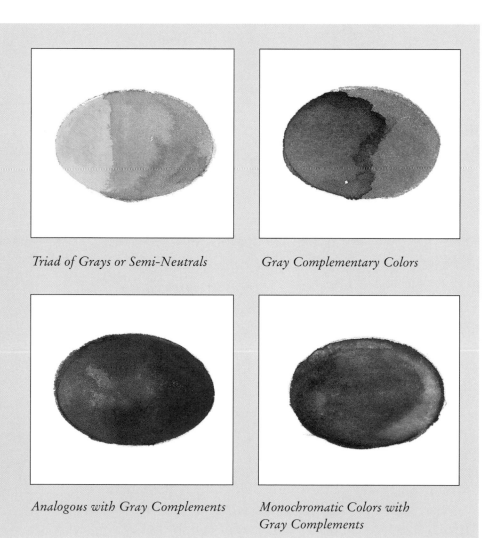

Triad of Grays or Semi-Neutrals

Gray Complementary Colors

Analogous with Gray Complements

Monochromatic Colors with Gray Complements

Analogous You can gray these colors, which are close to each other on the color wheel, by mixing their complements.

Monochromatic In a one-color scheme, such as blue, you would gray or darken the area by using its complement, in this case orange.

Split Complementary Achieve a split-complementary color scheme by choosing one color and using the two colors on each side of that color's complement on the color wheel. Use the complement of the middle color to gray the mixture.

Split Complements

MIXING MUD

IT'S QUITE EASY for beginners to inadvertently create "mud" when mixing and applying color. Muddy colors, or colors that lack light, can be avoided if you initially stick to two-color mixtures and use transparent colors.

Mixing three primary colors together will create a muddy color unless the mixture is handled very carefully.

Mixing complementary opaque colors can result in mud even more frequently. The sediment in the mixture will prevent the white of the paper from shining through. To prevent this from happening when mixing grays from a complementary pair of colors, make sure that you allow one color to slightly dominate the mixture.

Mud also can result from layering or glazing one color over another. If you first lay an opaque color and then glaze another color

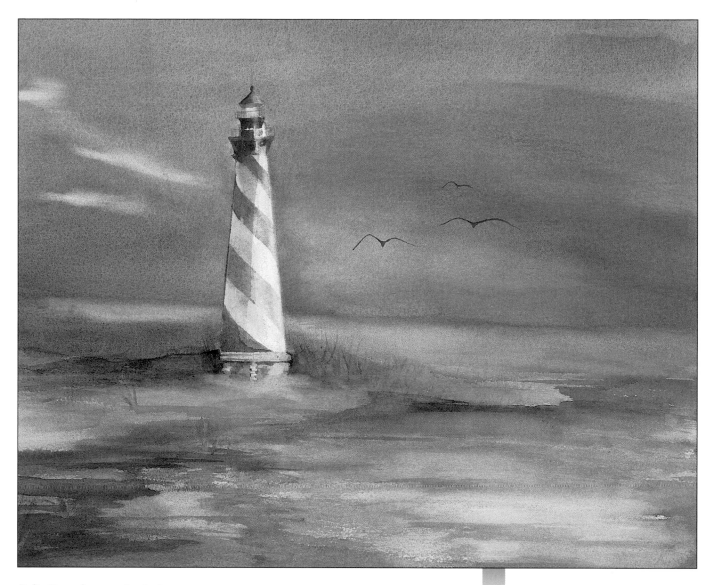

Split Complements in Action

Before the Move
Marcia Moses, 22×30 inches

on top, the first layer will be disturbed and mix with the next layer, creating a dirty color. This is why it's important when layering or glazing to apply opaque colors last and to use staining colors as the under layers.

On the other hand, "mud" is a relative term and can only be truly assessed in relation to surrounding colors. Sometimes a muddy color may be exactly what is needed in a certain painting. In these cases, the artist has deliberately chosen to create a muddy color to achieve a specific effect or to set off other, brighter, colors.

Drawing on Your Own Creativity

PAINTING WITH PASSION

Do you know what draws out your passion? How much do you want to paint? Does your inner desire dictate what you do? Do you allow yourself to have those things you dearly want? If you answer yes to any of these questions, you're well on your way to painting with passion. Painting with all your heart may help you find a place for your soul to live.

When painting, it's sometimes good to break the rules. You may feel that rules tend to hinder creativity. Of course, some rules are

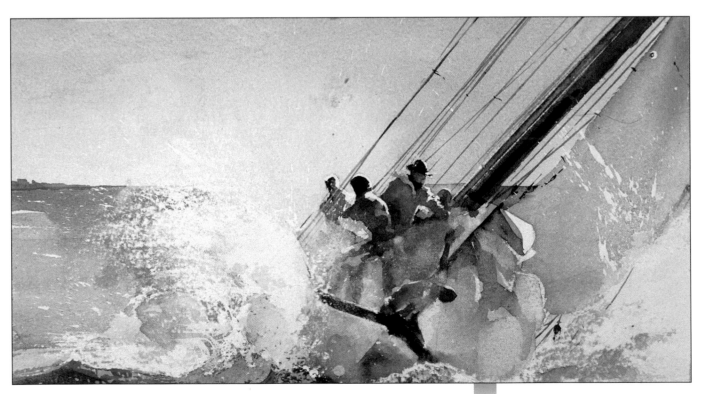

Winning
Paul George, 42 × 44 inches

helpful and challenge us to do our best. We may want to avoid what Robert Frost described as "playing tennis without the net." But whatever ignites your creative fire, use it, and allow your fire to burn freely without constraint. Don't believe in "never." When you adopt a positive attitude, your creative juices will flow and allow you to discover new sources of inspiration and to deepen your passion.

DISCOVER THE CHILD WITHIN

THERE'S SOMETHING wonderful about watching a child play. When my grandchildren visit, I like to sit on the floor and play with them to discover what interests them and why. I catch their excitement and live for a few moments in the joy of being a child again. As adults we're fettered by so many strictures, inhibitions, and both formal and unspoken rules. Many artist's compositions, shapes, and designs are too often governed by old traditions and current schools of thought. We fear not conforming to conventional notions of what art should be and what it should look like. Or we imitate other people's great ideas instead of creating an original work. Very young children enjoy creative play in many ways that we as adults no longer can. In play, they invent their own rules and enjoy greater freedom.

Pretend that you're a child again. Color in a coloring book. Break adult rules of structure; color outside the lines. Cows can be blue and skies green. Just play. Enjoy the overwhelming feeling of release when you flee the adult world and allow the child inside you to come out to play. Forget about the unwashed dishes, the unwritten letters, your grocery list for a dinner party,

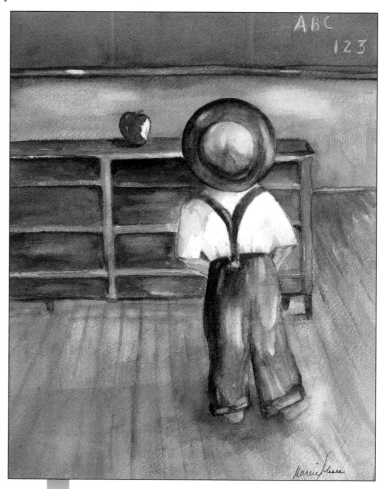

Guilty
Marcia Moses, 11 × 14 inches

Drawing on Your Own Creativity **63**

changing the oil in the car, the unfinished project at work. When we rear our own children, the many things we need to do can seem enormous. We forget how to be children.

Come into the child's world. See what a child might see. Everything is new; every small thing can seem intriguing.

If you're having trouble getting creative juices flowing, play with a child. Imagine with a child and listen to the child's stories. Go to the moon; believe in the tooth fairy or in Santa again. Rediscover magic.

In your wildest dreams, you could not imagine how this will set your creative soul free. You'll soon learn to walk and talk again and to see in a way you never thought possible. Discover the gold mine within you. You'll be able to extract all the necessary ingredients. Be the child within. Don't be afraid to dream.

Grandma and Me
Hayden Moses, age 7

Haley's Magic
Haley Moses, age 5

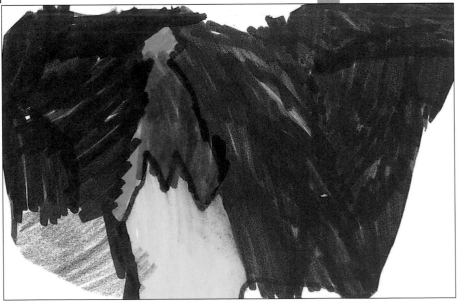

THE VIEWER'S RESPONSE

HAVE YOU EVER ADMIRED a painting but weren't sure why? We usually talk about an artwork's design, content, or overall composition. But that's often not what really stirs us.

When a painting evokes my deep feelings, I can't take my eyes off it. This emotional response pays the artist a high compliment. I love to feel moved when viewing another artist's work and to be able to touch someone's emotions through my paintings.

How do artists discover how to evoke viewer's feelings and connection to their paintings? That's difficult to explain. Of course, not all paintings that move me have the same effect on other people.

Gauguin's Cafe
Tom Lynch, 9 × 12 inches

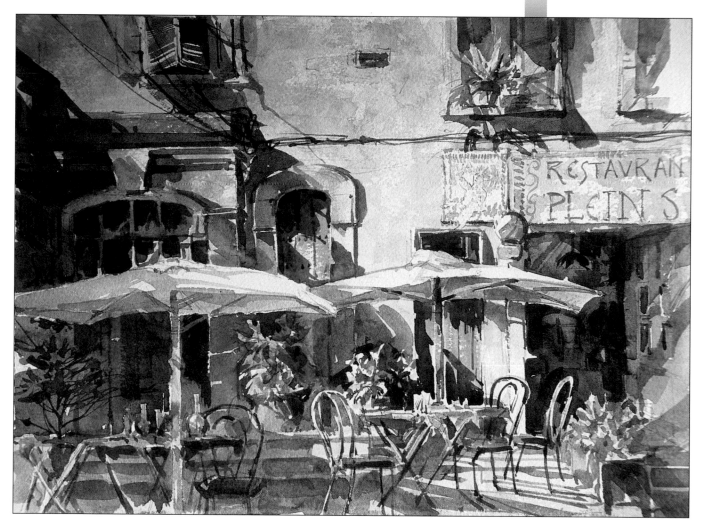

Arles, France, on-location study. "I experienced the color, contrast, and texture on location and created this scene with those feelings in mind. So your first reaction is to the mood and not to the objects."—Tom Lynch

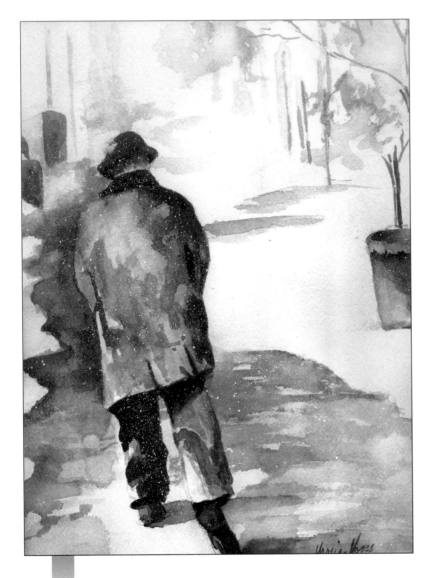

The painting "Dad" (left) was very difficult for me to paint because the more I painted, the more real my father's death became.

This watercolor began as a man walking through a snowstorm, and then I realized that the man in the painting was my father's image from the back. I remember when I was a child how I'd watch him leave for work or to play golf or maybe just go for a walk. At such moments, all my feelings of love, abandonment, and missing him flooded me as I wondered when he left whether he would come home again. Sometimes when you put your heart on a piece of paper, you reveal emotions that you normally keep hidden.

Although this painting draws on my emotions, the viewer will make up his own story. Keep in mind that you are telling a story with your painting.

The man walking away with his back to the viewer draws us into the painting, perhaps sharing with him what he sees and where he goes.

Dad
Marcia Moses
11 × 14 inches

American painter Andrew Wyeth's "Christina's World" both describes longing in the subject and evokes a kind of empathetic longing. This incredible work of art still makes me melt with emotion. In the painting, Wyeth tells a complex story with a simplified composition. He draws me into the painting with the questions: What is this desperate woman reaching for? Is she crying out for help from someone? I just want to walk right into the field where she lies and help her. While this is my emotional response, yours may be a little different. In any case, both of us would recognize the yearning and seeming isolation that Wyeth so perfectly describes.

It's exciting to see how an artist can create such palpable expressions on a simple piece of paper or canvas with paint. It's why we're so drawn to art. Great art expresses the soul in ways we cannot in our everyday lives.

What Stirs Emotion

The highest compliment viewers can give me, as an artist, is that they see me in my work. That tells me I've put my heart and soul on paper. When I see a sunrise over the ocean, a new baby, a lighthouse, the first flowers of spring, two people in love, or a painting that comes from the heart, my awe, delight, wonder, love of beauty, and other feelings are aroused. I could elaborate on what stirs my feelings, but I want you to ask yourself what moves you. Take that as your subject and paint it. If you paint with feeling and paint your emotions, you'll be inspired at how inspired you'll become.

ARTIST'S TIP

Explore your feelings, deep inside, and use what you discover to create art.

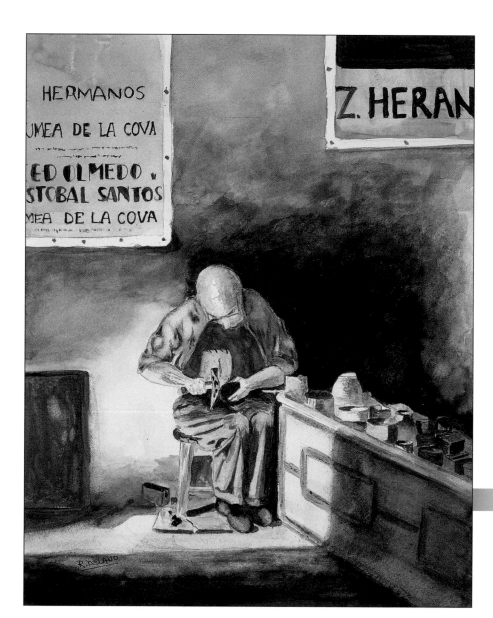

The Cobbler
Bob Delano, 11 × 14 inches

Vibrant colors, like red or bright yellow, in a sunset may excite us. Figures painted in muted colors may draw on wistful desires for love and romance. Fresh springlike pastels may cheer us. Dark, somber colors may help define grief or express the depraved and horrific. The bold, hard edges and colors of pop art and advertising may quicken our response. Diagonal lines and active brushwork may suggest dynamism, movement, or spontaneity. Expressive distortion and caricature may offer new ways of seeing and social criticism.

While we're all different in what excites or moves us, we'll want to draw on the deep feelings that make us who we are. If we can express the very core of our being in paint, we couldn't ask for more.

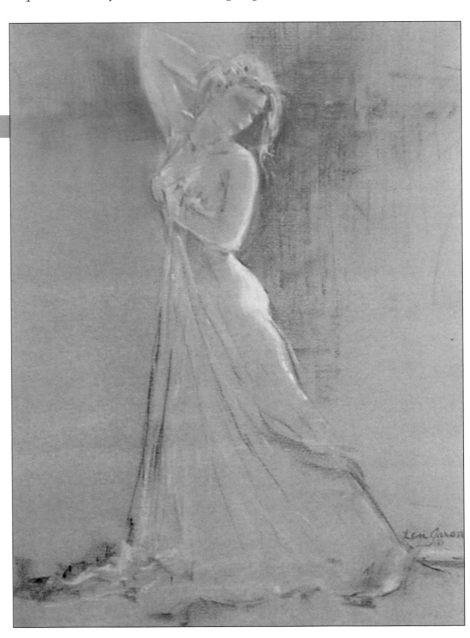

Looking Back
Len Garon, 14×19 inches

CREATIVITY

YOU MAY HAVE ALWAYS known that you were creative and wanted to paint but didn't know exactly how to tap into your creativity. I always knew that I wanted to paint, but for many years I didn't realize that my desire simply wasn't great enough. Perhaps, like you, I'd occasionally pick up a sketchbook and draw. I'd play with paint or I'd work on an oil portrait. However, I didn't get really excited or passionate about my art.

Many years later, when I had lots of time, I decided to paint with watercolor to keep busy. This began my passionate adventure in the art world. Suddenly, my desire grew. I read every book on watercolor I could find. I began intensive study with other painters and often painted as many as 12 hours a day. I painted everything I saw. I traveled across the U.S. to study the work of masters and to learn their techniques and theories, which I applied to my own work.

"A life without risks is a life unlived."

—HENRI MATISSE (1869–1954)

Winter Pansies
Marcia Moses, 8 × 10 inches

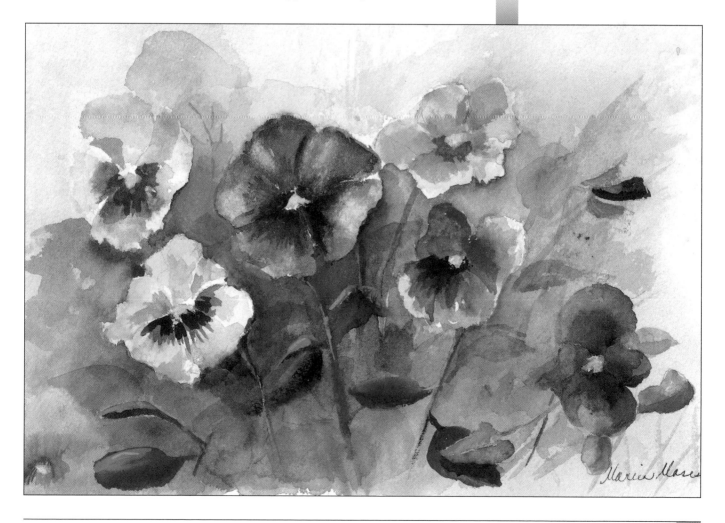

I grew so passionate about watercolor that I sometimes forgot to eat or sleep. Finally, I had discovered a place for my soul to live. The desire to create helped me to grow as an artist.

In the past, learning new things had seemed like work. But my passion meant that I wanted to devour every scrap of knowledge, try every technique, and perfect the many ways of seeing and expressing myself in this wonderful medium. It was joyful and fulfilling. When you begin to visualize yourself as an artist and to know what you need to do to make that dream a reality, you're on the road to discovering how to bring your world to life on canvas. You'll begin to see, feel, think, frame, and paint as an artist.

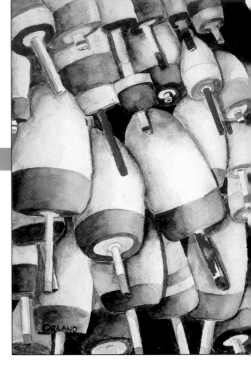

Lobster Pots
Bob Delano, 16 × 20 inches

"Every child is an artist. The problem is: how to remain an artist after he grows up."

—PABLO PICASSO (1881–1973)

America's Cup
Len Garon, 22 × 28 inches

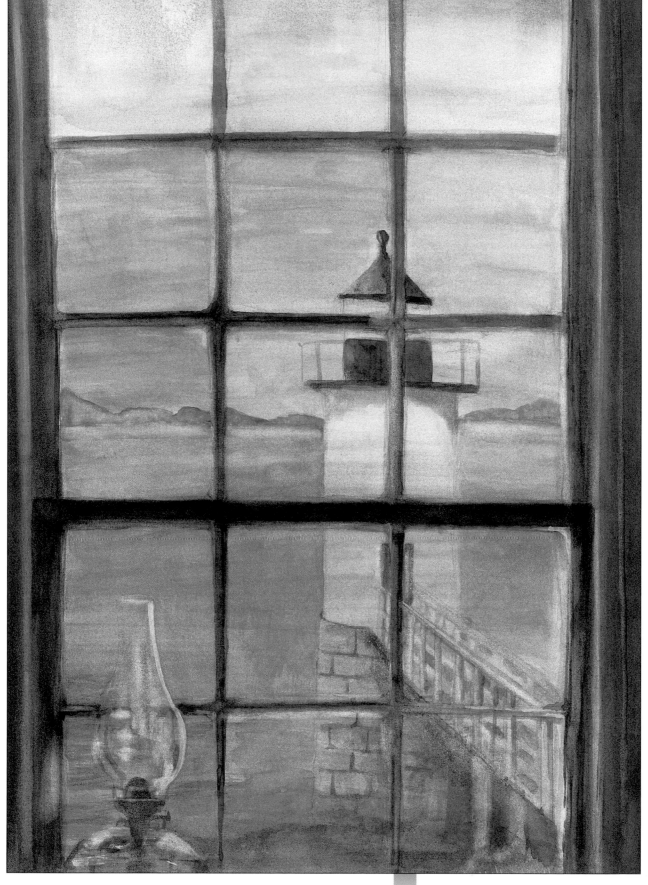

Isle au Haut
Marcia Moses, 16 × 20 inches

REVISION

THE WONDERFUL THING about creativity is that it is derived from a view of life that's constantly changing. How we see a painting today is not necessarily the way we will envision it tomorrow, and most definitely, that's not the way we will look at it weeks or months later.

"As in life, we are in art, always becoming," artist Wanda Montgomery likes to say. "We're always trying to improve everything we do."

Time and knowledge will change an artist's outlook, not only in paintings we've planned, but in paintings we've completed.

"I could keep taking the frames off every painting I do and changing them," Wanda explained to me one night when she was showing me that she had done just that to her painting of a bicycle, "Child's Play."

"I try not to do this to every painting, but I have returned to several and improved them," she said.

"With 'Child's Play,' I decided to try to improve the painting by simplifying it, removing the background wheels, darkening the color of the bike, and making the foreground a deeper color by glazing. I put more impact on the center of interest."

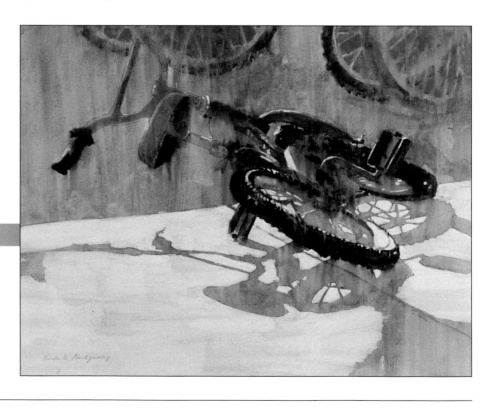

Child's Play, original painting
Wanda Montgomery
15 × 20 inches

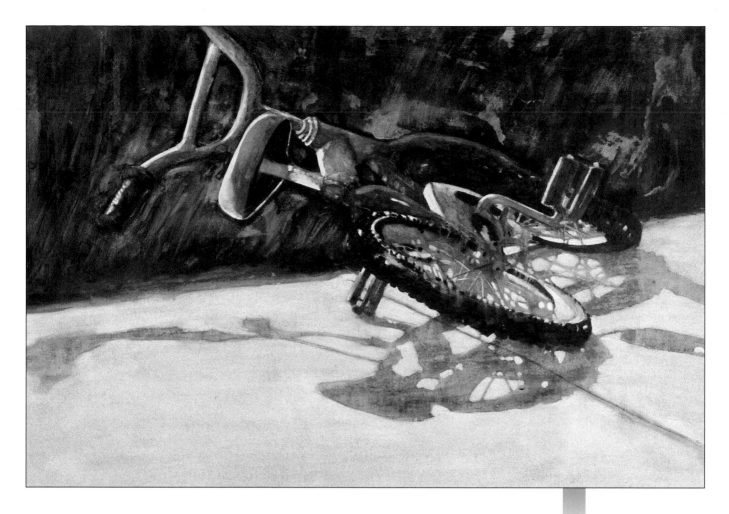

Her effort, taken more than a year after the painting first was "completed," served her well. The second version of the painting won an Award of Excellence at the 2000 Ohio Watercolor Show. So it is true: sometimes less is more.

FINDING A SUBJECT

IS THERE SOMETHING you've always wanted to paint but didn't know how to begin? Have you ever seen a big, brooding apple tree in winter, sand washed with waves, or ice-capped mountains against a grassy valley that you were dying to paint? If you're like me, your excitement made you feel you wanted to reproduce not simply the image but your feelings on paper. This inspiration and excitement breathes life not only into you as an artist but into the painting you'll create.

I know that feeling. I cannot rest until I teach myself how to paint what inspires me. Fortunately, I've had very patient teachers who have given me the tools and shown me the techniques to achieve what what I wanted on paper. But I've found that I've still needed to do the work.

I love spring lilacs. I've wanted to paint them so much that it hurt. I asked every painting instructor I had how I could paint lilacs. I always received the same answer: "Paint what you see."

At a watercolor workshop, I asked the same question and got an unexpected answer. It wasn't the one I had longed to hear, but it really was the perfect answer. The instructor told me to paint how I felt about lilacs. At the moment, I was angry with him because I thought he was brushing me off. But his words are probably the best advice I've ever received in a workshop.

I thought long and hard about what he said. I began to think about what I felt when gazing at lilacs, enjoying their beautiful colors, and smelling their wonderful fragrance. I observed how they flow into cone shapes and how they almost jump off the paper when I paint them. The way I feel about lilacs became my inspiration for painting them, and I finally knew what I needed to do to reproduce those feelings on paper.

Whenever I have an urge to paint something, I apply the watercolor instructor's advice. I explore my feelings about the subject, and then, like magic, the subject and my feelings begin to appear in paint on paper.

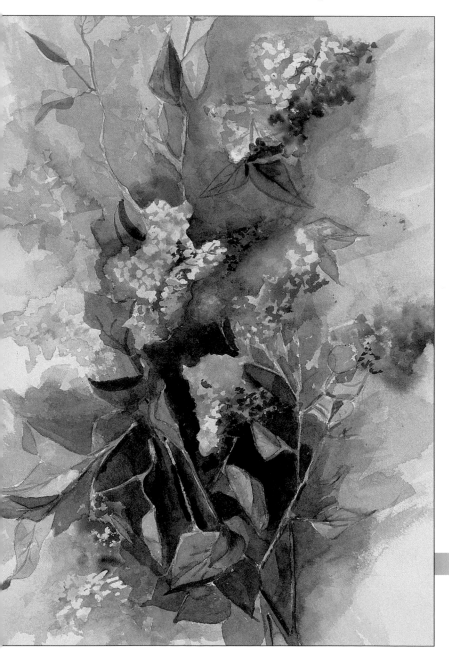

Fresh Picked
Marcia Moses, 22 × 30 inches

INSPIRATION

MY FAVORITE PAINTERS inspire me because I can see the artist's soul in his or her work.

Artist Alex Alampi, Jr., for example, mesmerizes me with even a simple subject. When I asked what inspired him to paint "Float Collection," he said, "I love to paint any subject with a marine feel to it." The weathered shed in "Float Collection," with its colorful assortment of crab floats, is located on Delaware Bay in a small fishing village. In this watercolor, the viewer's eye is directed to the sunlit floats by a mid-value background and dark, dramatic clouds, providing a clear focal point for the painting.

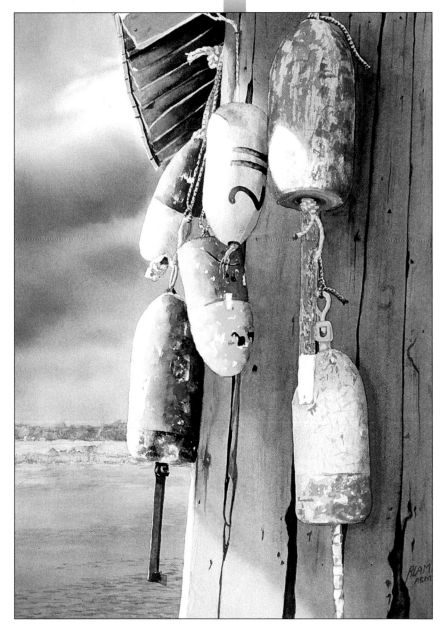

Float Collection
Alex Alampi, Jr., 14 × 20½ inches

The painter Paul George, on the other hand, inspires me with his use of color as much as his choice of subject. Paul leads the viewer into his paintings with vivid color, delicately used. In "Swim Beach" (p. 76), Paul pulls the viewer up the hill with his colorful assortment of dories, carrying the eye toward his focal point, a weathered house at the top.

In my studies with Paul, I learned the importance of a limited palette. He can take a few colors of paint—transparent colors that create brighter brights—and make his paintings come alive. He is a trusted friend and terrific teacher.

Wonderful friend and teacher Jim Penland normally paints in acrylics. He allowed me to teach him watercolors, but I ended up being his student. His very first painting in my watercolor class, "Longport Reflections" (p. 77), amazed me with his use of color to create unity. His delicate shapes and vivid background inspired me.

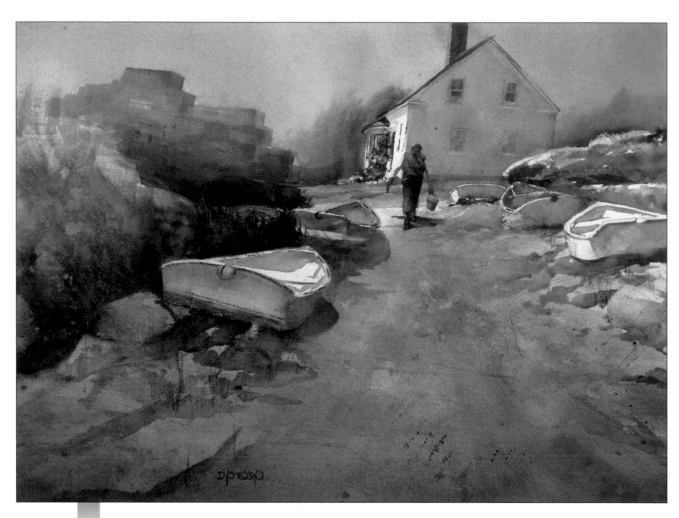

Swim Beach
Paul George, 22 × 30 inches

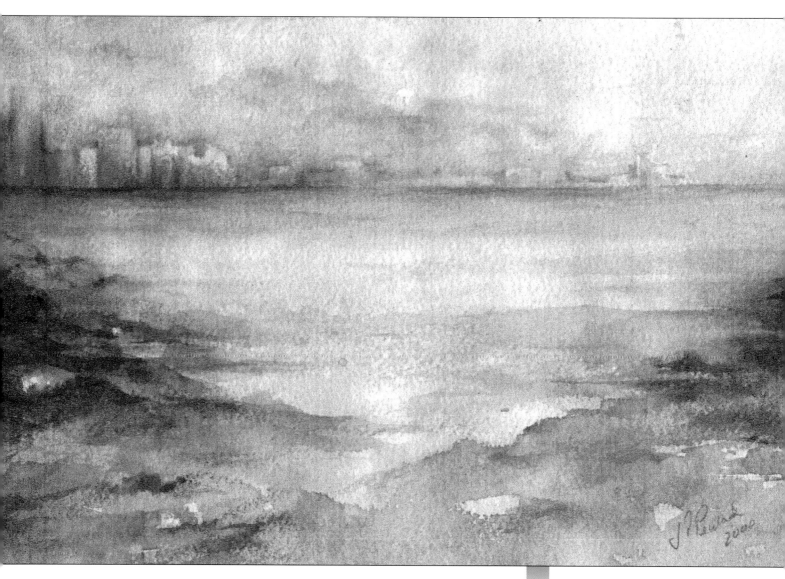

Longport Reflections
Jim Penland, 8 × 10 inches

Dali's Secret

"Secret number 50 is this: that when you have learned to draw and paint without mistakes, when you know how to distinguish the sympathies and the antipathies of natural things with your own eyes, when you have become a master in the art of washing and when by your own resources you are able to draw an ant with the reflections corresponding to each one of its minute legs, when you know how to practice habitually your slumber with a key and the so hypnotic one of the three sea peach eyes, when you have become a master in the resurrection of lost images of your adolescence, thanks to the natural magic of the retrospective use of your aranearriums, when you have possessed the mastery and the most hidden virtues belonging to each of the colors and their relations to one another, when you have become a master in blending, when your science of drawing and of perspective has attained the plenitude that of the masters of Renaissance, when your pictures are painted with the golden wasp media which were then as yet unknown, when you know how to handle your golden section and your mathematical aspirations with the very lightness of your thought, and when you possess the most complete collection of the most unique curves, thanks to the Dalian method of their instantaneous molding in dazzlingly white and perfect pentagons of plaster, etc., etc., etc., nothing of all this will yet be of much avail! For the last secret of this book is that before all else, it is absolutely necessary that at the moment when you sit down before your easel to paint your picture, your painter's hand be guided by an angel."

—SALVADOR DALI (1904–1989)
from "50 Secrets of Magic Craftsmanship"

ARTISTIC LICENSE

Why Did You Put That There?

On a miserably hot day on the boardwalk of Cape May, New Jersey, in the throes of an exhibition, I was approached by what I thought was a potential customer. Having a smile on my face, in spite of the horrid heat and humidity, I introduced myself to her. In a loud squawking voice, she screamed at me, "Why did you put that there?"

In my astonishment, I realized that she was referring to my most recent painting, with which I was quite happy. It depicts the beautiful Victorian homes of Cape May, in front of the Cape May lighthouse. Those familiar with it know that the lighthouse is not visible from the front yards of these lovely houses. The lighthouse is on the other end of the cape. But I tried, in my kindest voice, to explain that artistic license had been employed, allowing me to put my feelings about Cape May, one of my favorite places, on the canvas, encompassing both the lighthouse and the houses in one scene.

She was adamant that this was wrong. I had no right to paint these two landmarks together. I will always disagree with her. My heart urged me to put these beautiful things together on my watercolor paper, even though they were miles apart in reality.

Cape May
Marcia Moses, 10 × 22 inches

Time-Honored Techniques

PUTTING THEORY TO WORK

Now that we've learned about composition, design, color, values, and other important basics, we're ready to apply these theories to painting. Artists use a wide variety of techniques. Let's consider many techniques that both beginners and more accomplished artists can use effectively and successfully.

When beginners first apply paint to paper, they often feel frustrated when trying to create what they visualize. When I began painting, I often looked at paintings by experienced artists and wondered, "How did he get that sky to look so wonderful?" Or I would think, "That looks like a real tree. How did she do that?"

Of course, technique is the answer to those questions and to others that plague beginners. While there are countless painting styles, all use many basic watercolor techniques, such as washes and controlled drip, or even throwing, spattering, and pouring. Your painting may have a perfect design and a well-developed plan, but these won't be evident on paper without a working knowledge of the basic techniques necessary to achieve your artistic goal.

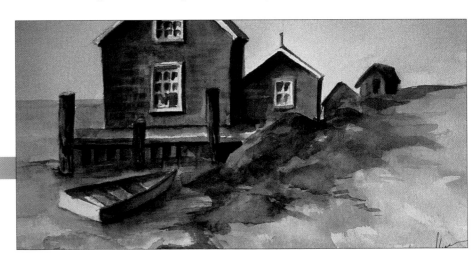

Martha's Vineyard
Marcia Moses, 11 × 14 inches

BASIC WASHES

ARTISTS USE FOUR BASIC washes to cover large areas of paper. They are wet on wet, wet on dry, dry on wet, and dry on dry.

Wet on Wet

This wet-on-wet technique refers to applying wet paint on wet paint or applying wet paint on dampened paper. For wet colors to mix properly on the paper, the color and the water both need to be equally wet. If the water on the brush is too wet, the color will almost disappear on the paper. You can use this wet-on-wet technique to produce such effects as a sky with blended colors or water that appears mirrorlike.

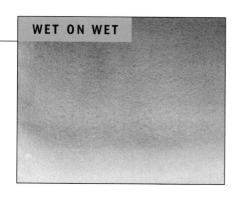

WET ON WET

Wet on Dry

With the wet-on-dry technique, the paper will absorb the wet paint and allow you to control where you put the paint. With this process you'll get hard edges.

The wet on dry technique works nicely for some parts of the painting, but you'll also want to use other methods of applying paint to create soft edges that will be more pleasing to the eye.

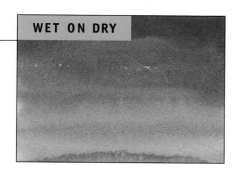

WET ON DRY

Dry on Wet

For the dry-on-wet technique, use moist paint on a damp brush with all excess water squeezed out and paint on wet paper. You will be able to achieve a diffusion that will push elements into the background. This is great for background foliage, stands of trees, or mountains seen in the distance.

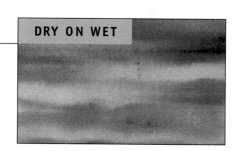

DRY ON WET

Dry on Dry

For the dry-on-dry technique, load a brush with thick paint and brush over dry paper. You'll achieve best effects on rough paper.

This technique is useful for creating definition and texture. I use the dry-on-dry method to apply texture to trees, rocks, weather-beaten boards, and other objects.

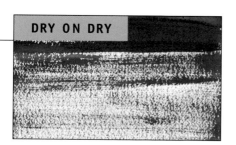

DRY ON DRY

GRADATED WASHES

There are two types of gradated washes, **tonal** gradation and **color** gradation.

- **Tonal wash** gradates from dark to light by adding a small amount of water to the brush each time you make a stroke. It uses a single color of paint.
- **Color wash** gradates from one color to another.

For the tonal wash (on this page, below), I loaded my brush with vermilion and applied one stroke. Then I dipped my brush gently into the water and made another stroke. Continue this procedure as far down the paper as you want the tonal wash to go.

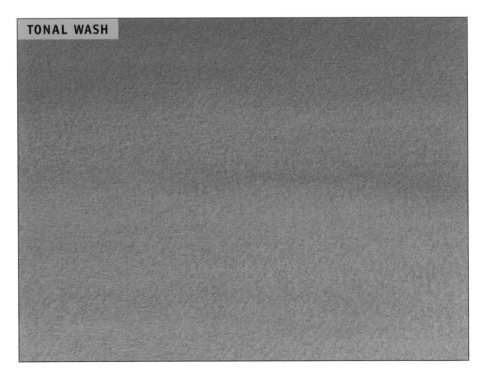

TONAL WASH

For both color washes on page 85, I used cadmium yellow light and cobalt blue. After wetting the entire paper, apply a wash of cadmium yellow light to half of the paper. Turn the paper upside down and apply a wash of cobalt blue down into the edge of the yellow. Turn the paper to allow the colors to mix. Lay the paper flat when you get the results you want. This technique is often used to create spectacular sunsets.

These color washes (right and below) use the same two colors of paint, cadmium yellow light and cobalt blue, with rather different but equally appealing results.

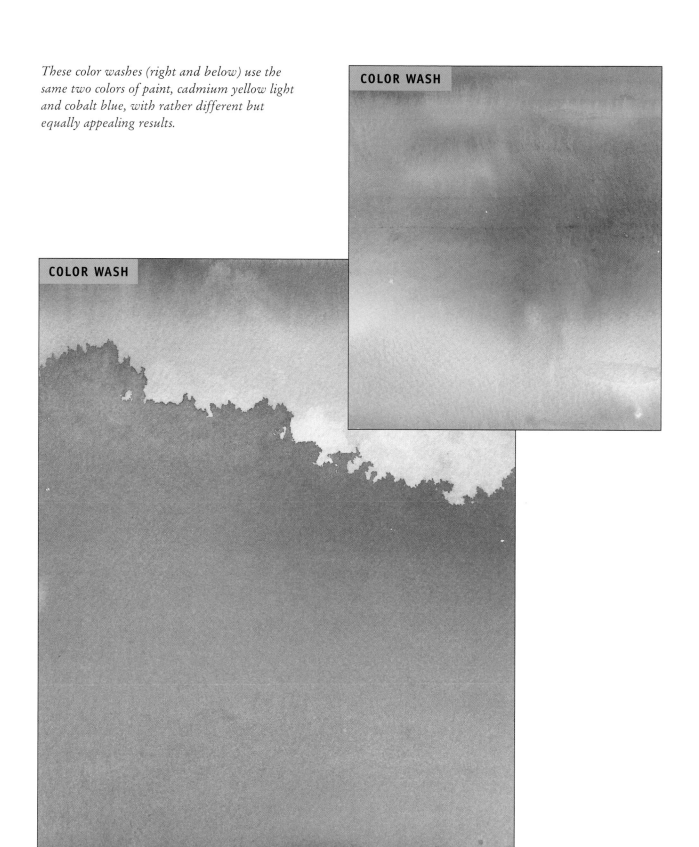

COLOR WASH

COLOR WASH

NEGATIVE PAINTING

WATERCOLOR, A UNIQUE and challenging method of painting, has gotten a bad reputation for being a difficult medium to work in. Novices may have had this notion because they didn't take the time to learn proper watercolor techniques. On the other hand, a few experienced and vain artists who wanted others to imagine that what they did was extremely difficult may have added to watercolor's reputation. However, watercolor painting is no more difficult than any other artistic medium as long as you know how to use water-color techniques to achieve your desired results. You can control your watercolors or you can let them control you.

It is true that watercolor may be more unforgiving because it's tougher to hide mistakes than in, say, oil painting. A successful watercolor does require planning.

Negative painting involves painting in areas surrounding objects to which you want to draw viewers' attention. It's one of the most important techniques you'll ever learn for controlling watercolors and requires a little patience and planning to use it to your advantage.

ARTIST'S TIP

If a wash does not hold, use less water.

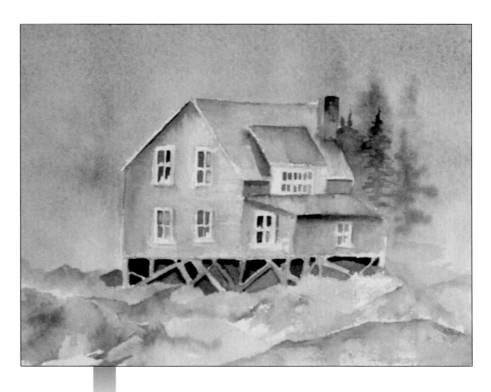

Monhegan House, unfinished painting
Marcia Moses, 11 × 14 inches

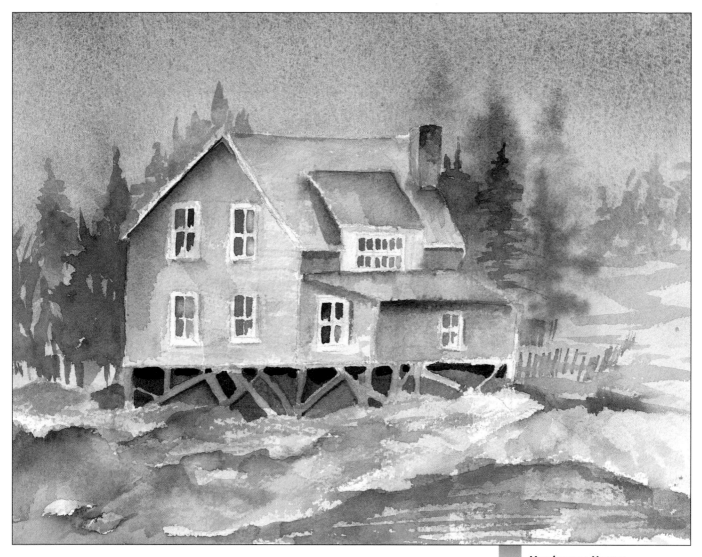

**Monhegan House
finished painting**
Marcia Moses, 11 × 14 inches

When correctly used, however, the results of negative painting will satisfy you and appeal even to casual viewers of your work.

Consider the watercolor "Monhegan House" for an example in negative painting. Here are two versions. The first shows the unfinished painting (on p. 86) with light and dark next to each other below the house already added.

In the second version (above), I've painted trees behind the house in a darker color for contrast, and I've painted a darker shade of blue at the bottom of the painting to make the rocky area and the house come forward. This was also negative painting. I added dark hues, which enhanced the lighter areas of the watercolor. Dark areas recede, and light areas come forward.

Controlled Drip

In this painting of a tree, I used the controlled drip method to allow the paint to blend on the paper.

1. I began by drawing the tree, sketching only minor details, just enough to create the dominant shape. With a brush, I spread water on the places where I wanted the paint to flow.

ARTIST'S TIP

To get paint to move on paper, spray it with water and tilt your board.

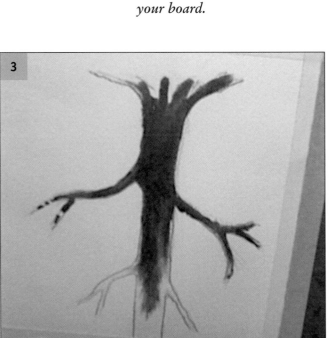

3. I could have applied the paint from the top of the tree and let the paint flow from the top, from dark to light, although this time I chose to do the opposite. I held the painting upside down and let paint flow from its bottom.

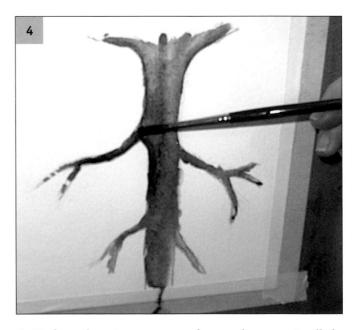

4. To force the paint to move and cover the paper, I pulled it with my brush.

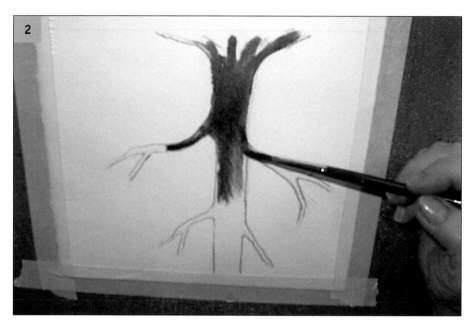

2. *Then I loaded the brush with a mixture of ultramarine blue and burnt sienna. I turned the paper upside down and began to apply the paint. I gently allowed the water to pull the paint from the brush. I was not actually brushing the paint; I was coaxing the paint to move. Tilting the board forced the paint to flow on the watered surface, but the paint stayed within the watered perimeters of the drawing.*

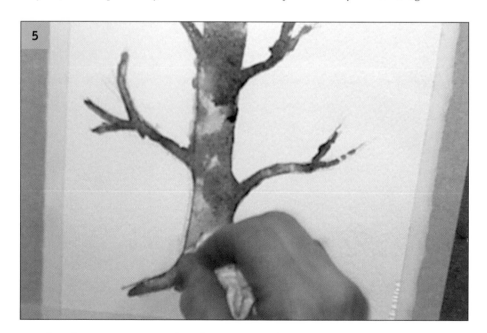

5. *After the tree was covered with paint, I used a crumpled tissue to lift paint in a pattern of lights and darks to give the tree three-dimensional form and create movement.*

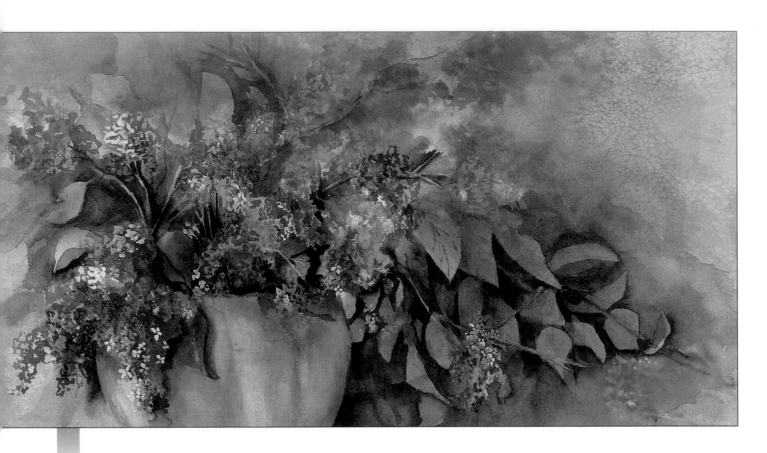

Lilacs
Marcia Moses, 22 × 30 inches

SPATTERING & THROWING PAINT

SOMETIMES I LOVE to throw paint on my white paper and then figure out where to go next. This exercise not only gets the juices flowing; it can be a great way to let off steam.

There are a lot of different ways to throw or spatter paint. You can create large spatters with a very wet brush that's loaded with paint by flicking your wrist at the paper. Or create smaller spatters by tapping the end of the brush against the wrist of your other arm. For an even smaller spattering effect, draw your thumb over the bristles of a paint-laden brush pointed at a particular area of your paper.

In the painting "Lilacs" (above) I began without a plan and just threw paint on my paper. Mixing alizarin and royal blue makes a beautiful violet.

In the painting "Pots" (p. 91), I began by throwing and spattering three colors: ultramarine blue, aureolin yellow, and burnt sienna. I saw lots of textures begin to emerge, so I decided to play on that by adding many intertwining shapes.

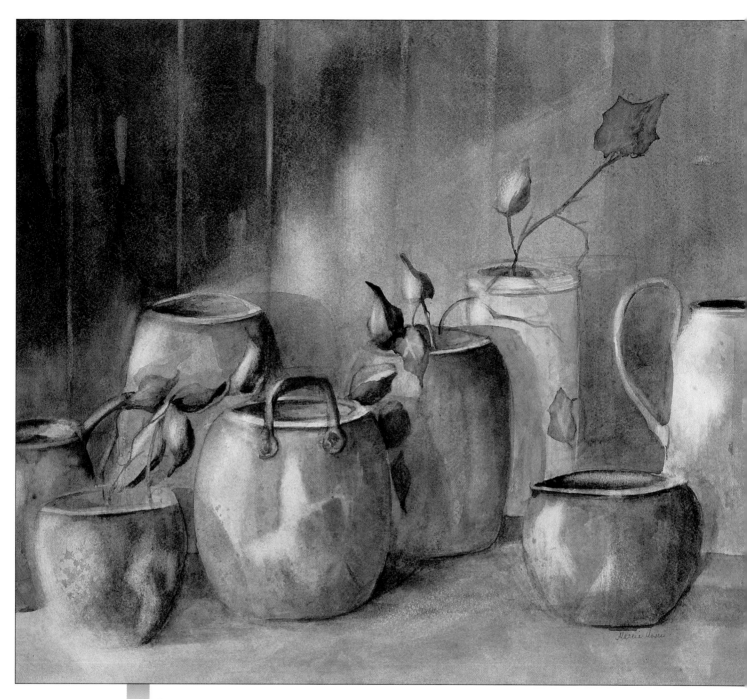

Pots
Marcia Moses, 18×24 inches

GLAZING

GLAZING IS A TECHNIQUE, using transparent paints, that maintains the paint's luminosity and allows lights to shine through. This happens when you apply a very thin layer of transparent paint to watercolor paper, allow it to dry, and apply the next layer of paint (whether of the same color or another color). For glazing, do not mix colors. Use only transparent colors to prevent mud.

Drying is the most important step in the glazing process. When you dry paint, it sets the color. That means that this color will not be disturbed by the next color you apply. The result is that the first color shines through the second and so on. I have used as many as fifty glazes in a single painting, and the colors keep shining through.

If the glaze (transparent paint layer) dries naturally, it will take a few minutes. If you use a hand-held (blow) hair dryer, you can dry the glaze very quickly.

In the painting "Pots" (p. 91), I moved into the background to apply glazes beginning with aureolin. I added glazes of burnt sienna and ultramarine blue. After another drying, I began again with thin layers of each color. I dried between glazes to preserve their transparency.

Glazing allows you to apply many thin paint layers, and it helps prevent colors from becoming muddy. Keep in mind that you need to think out each layer you glaze. For example, if you glaze a layer of yellow, and then add a blue glaze, the color that results from the second layer will be green.

Glazing (Dry between glazes.)
cadmium yellow light +
rose madder + cobalt blue

Glazing (Dry between glazes.)
2 glazes of cadmium yellow light
+ 1 glaze of cobalt blue

LAYERING

In watercolor, layering uses much the same technique as glazing but with different results. That's because you do not dry between paint applications. Therefore, if you apply the first layer or wash of paint, then immediately the second and third layer without drying, the colors will mix on the paper, intertwining and creating magical effects. This technique of mixing wet on wet paint can fashion beautiful skies, wonderful sunsets, and numerous other exciting creations.

Practice with different transparent colors using only the three primary colors until you're comfortable using the layering technique. Avoid using opaque colors for layering, just as you would for glazing, to prevent mud.

Layering
Wet on Wet: cadmium yellow light + rose madder + cobalt blue

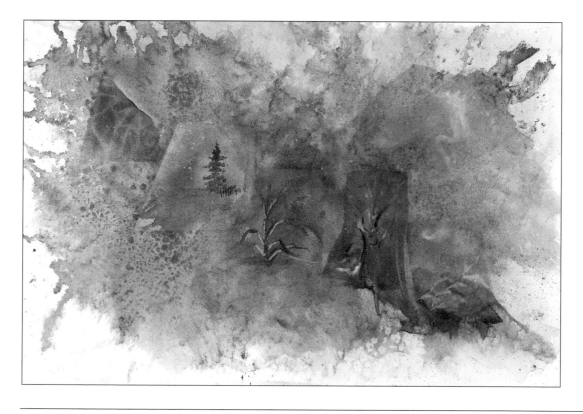

CREATING TEXTURE

AFTER YOU'VE LEARNED watercolor basics, you can begin to add texture and dimension to your paintings. Many texture techniques are fun, and you'll be happy with the results.

When working on a painting that still hasn't yet come alive, consider whether it could be improved with texture. Texture can provide the illusion of three dimensions, raising a painting out of a flat two-dimensional surface and imbuing it with lifelike qualities.

In the watercolor "Stars and Stripes" (below), artist William Persa makes it possible to almost feel the texture of the soft, worn cloth flag against the old, battered wooden building. When I saw his painting, I wanted to capture what I saw and felt. The painting moved me with its incredible texture. And, I must confess, the composition drew on my patriotism and filled me with emotion.

Stars and Stripes
William Persa, 22×30 inches

Watercolor techniques like *spattering, spritzing, glazing, dry brushing, lifting off paint,* and *scraping* allow you to create just the right texture for rocks, trees, water, weathered wood, flowers, foliage, fences, and whatever else you may need. Artists often use the dry-on-dry technique, using a dry brush with more paint than water on dry paper, to add definition, depth, and appealing texture to their paintings.

For *lifting paint off* or out of paper, tools that work well include a wet brush, dry brush, sponge, facial tissue, paper towel, cotton swab, eraser, brush handle, or sandpaper. Most tools can work on wet paint. If you use sandpaper, first let the paint dry. You can also create texture by using a razor blade, putty knife, spatula, wax paper, stamp, alcohol, bleach, or even tap water.

For *scraping off paint,* common household tools, like a razor blade, putty knife, expired credit card, or small rubber spatula, do the trick. Be sure to use a safety handle with the razor blade.

These various texturing techniques help create definitive shapes, the illusion of depth, roughness, and smoothness. Most don't even require a paintbrush.

Brush handle on 140# Arches cold-pressed paper.

Old credit card on 140# rough paper.

Small spatula on 140# Arches cold-pressed paper.

Large spatula on 140# rough paper.

Water Spritz

Use water in a spray bottle or atomizer to spritz on snow, flowers, or the spray of a wave. The water helps move paint around on the paper. Spritzing with water will spread the colors out and leave lighter spots or allow colors to mix.

Spritz with water on 140# rough paper.

Salt

Salt sprinkled on wet paint absorbs color surrounding each salt crystal. After the paint dries, brush the salt from the paper to find the blossoms of light spots. Use various kinds of salt to create the desired texture. Table salt makes nice snowflakes, kosher or sea salt shapes flowers, and rock salt (used for melting ice outdoors) creates abstract, craterlike shapes. The larger the salt crystal, the more paint absorbed. Of course, the more salt you use, the more paint will be absorbed also. Ocean beach sand, which contains a lot of salt, also works nicely to remove paint from paper.

Table salt on wet paint with 140# rough paper.

Sea salt on 140# rough paper.

Rock salt on 140# rough paper.

Razor Blade

For this log, I applied wet paint into dry paint. First I used aureolin yellow and let it dry. Then I charged the brush with burnt sienna and a cobalt blue hue. I pushed the wet colors around with a razor blade, trying to create the log's characteristic ridges and bumps. I added a little detail with a #4 round brush.

Razor blade on 140# rough paper.

Sponge

Use a natural sponge dipped into paint to paint a stand of trees. Sap green mixed with a little rose madder over aureolin yellow created this group. To have a little more control, keep most of the sponge free of paint.

Brush Handle Tip

Here is a little exercise for painting grass that's gratifying for both beginners and professionals. Try these steps to create believable grass.

Painting Grass

1. *Apply a wash of sap green and charge your brush with a little aureolin yellow and a little rose madder.*

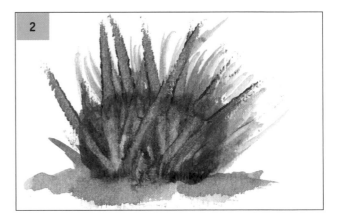

2. *Using the end of your fingernail or the flat end of a brush handle tip, scrape upward through the wash, beginning at the bottom, and pull the paint out and up above the wash.*

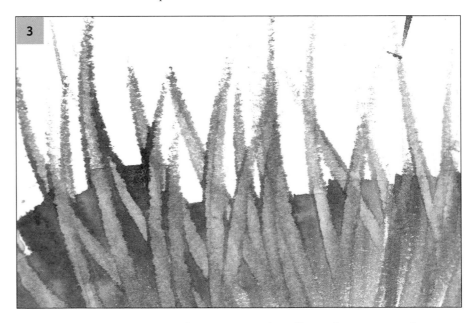

3. *The finished product shows how you can take a flat surface, paper, and create a three-dimensional object on it, grass. Use this technique to create texture on a variety of other objects you paint, including trees, rocks, and flower stems.*

Wax Paper

For this painting, I first used a wash of sap green over the watercolor paper's entire surface. Then I pressed wax paper down on the top half of paper and allowed it to dry. After I removed the wax paper, I found this incredible texture that pushed my imagination to work overtime. Could this be a forest, waterfall, or lake? Dozens of things seem possible.

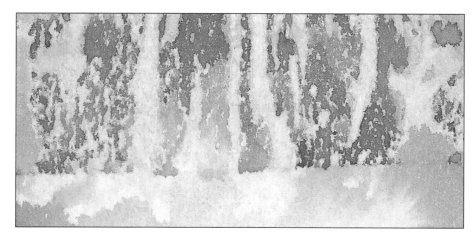

Wax paper used to remove paint.

Plastic Wrap

If you apply plastic wrap to wet paint on rough paper, then remove it, you'll discover interesting textures.

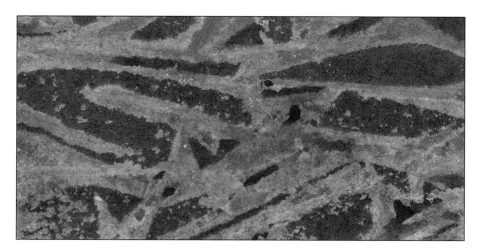

Plastic wrap on 140# rough paper.

Stamp

My earliest exercises in using a stamp felt like cheating. Don't worry; you'll have too much fun playing with great stamping tools to imagine that. Buy a few inexpensive rubber stamps from a craft store. Later you may want to make your own by cutting designs out of stiff illustration board with an X-acto knife.

For this forest of trees, I used my homemade stencil. I didn't feel a bit guilty that I didn't use a brush. Remember that there are many ways to create art. Feel free to use them to complete your painting. So, paint and stamp away. As long as you paint from your heart, there's no wrong way to create your finished work.

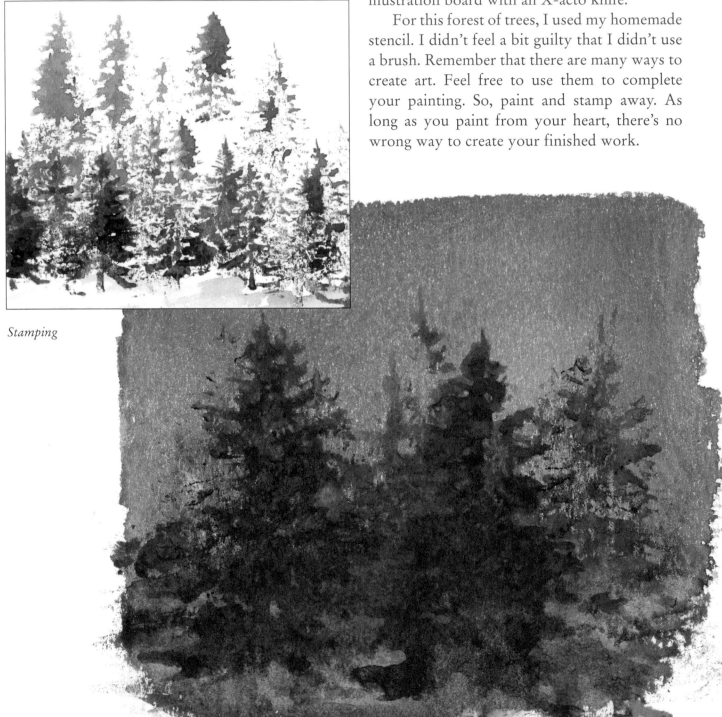

Stamping

Alcohol

Alcohol is the perfect substance for creating texture. With watercolor paint, alcohol can help move the paint and spread it into all kinds of shapes. Alcohol may also be used to remove or lift paint.

To create the bark's texture, I painted wet on wet paint. First I applied cobalt blue; then I charged burnt sienna into the wash and allowed it to mix on paper. Finally, I used a spray bottle containing alcohol, carefully spraying little shots into the paint to give the tree trunk and branches the look I wanted.

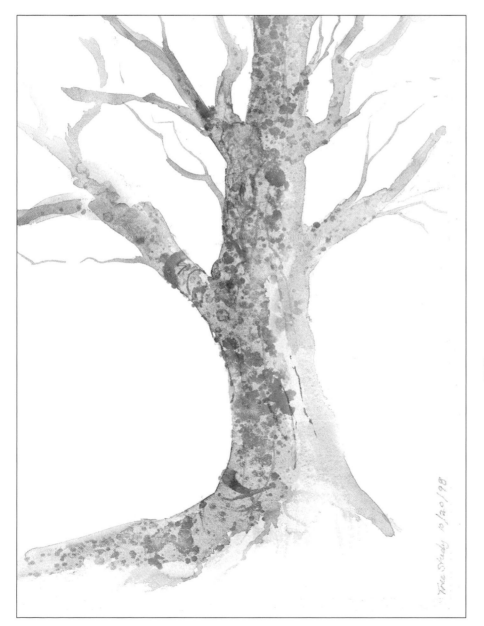

Alcohol for creating texture and removing paint.

ARTIST'S TIP

When lifting off color, use a clean facial tissue to prevent accidental mixing of colors.

POURING COLOR

OF ALL THE METHODS and techniques I use, pouring color is the most exciting and gratifying. Intentionally mixing color on paper with or without a plan can create wonderfully luminous effects.

Pouring allows you to create movement, mood, and texture. I pour color to create a mood, whether it's dark and cloudy or radiating sunshine, warmth, and beauty. In either case, I can get an effect that cannot be accomplished by merely stroking the brush on paper. I have always loved the surprises I get with pouring color.

To get the positive benefits from pouring, you'll need to prepare.

Choosing Paper

After experimenting with different brands and kinds of paper, I've found a few that work best for me. My favorite is Strathmore Imperial cold-pressed 500 series 140-pound paper. It does not hold poured paint as well as the other brands, but I like the results. Arches 140-pound cold-pressed paper takes pouring well and absorbs paint more quickly than Strathmore Imperial. Arches is more porous. Strathmore Imperial tends to take on a light coat of paint, which means that I usually pour onto this paper twice to achieve the desired luminosity. Strathmore Imperial paper is more forgiving than many other kinds of paper. To get back the paper's white, simply use a damp brush and lightly wash out the color. This technique doesn't necessarily work on other watercolor paper.

Stretching Paper

Before you begin pouring paint, soak the watercolor paper to remove some of its sizing (a material used to make the paper surface less absorbent). I usually soak my paper in the bathtub for about 10 minutes. (You can use a dish washtub, if the paper fits.) Then I remove it and staple it to a gator board or any other hard, durable surface to dry.

I've also had good experience with unprepared paper, although I highly recommend using stretched paper.

Golden Gate
Marcia Moses, 22 × 30 inches

Preserving Whites

If you have a plan when you pour paint, you'll need to preserve the whites you want to use. Masking fluid does the trick. (I prefer Incredible White Mask liquid frisket.) First use a soap without additives (such as Ivory hand soap) to wet and lather an old brush. Dip the lathered brush into the mask. With each new stroke, repeat this action.

Allow the mask to dry completely before you paint over it. The mask may take several hours to dry. After pouring or painting, you can remove the mask with a gum eraser and continue to paint. You can also apply the mask over paint to preserve certain areas or colors in preparation for a new pouring.

Mixing Color

To mix color for pouring, use a bottle, dish, cup, or another container. You'll discover new ways to pour on color. I've tried paper cups, ketchup bottles, plates, bowls, and many other household items.

Depending on the intensity you want, mix a strong color (four parts water to one part paint) or weak colors (eight parts water to one part paint). Decide what intensity you want and go from there. It's fun to experiment.

Pouring without a Plan

My painting "In a Pickle" (p. 105) doesn't follow a plan. First I prepared the paper and allowed it to dry. Then I re-wet it with a simple water wash and poured color, allowing the color to mix on the paper by moving the board up and down until the mix pleased me. After this dried, I discovered shapes and decided what the composition would say. Pickle jars seemed like a natural fit, so I pulled out pickle shapes with a #4 nylon brush and water. Because I used easy-lift paint, it was a cinch to create these shapes. If you pour with or without a plan, you'll want to check the paint's properties before you begin so that you'll know what patches of color you'll be able to remove or lift out.

When I finished my pickles, my husband commented, "I hope you don't plan to hang that in our home." Oh well, you can't win them all!

In a Pickle
Marcia Moses, 7 × 10 inches

When pouring with a plan, you'll want to think about each step before you begin work. Ask yourself:

- What is your **design** and what kind of shape do you want it to take?
- Where do you want to **preserve** whites?
- How **intense** do you want the colors, and what do you want them to say?
- Are your colors **transparent** and easy to lift from the paper if you want to control them a bit or avoid "mistakes"?

You'll want to know what your pouring will achieve. The technique can be a bit unpredictable, but that's part of its charm. If you do a little planning before you pour, you'll probably be more pleased with the results.

For "Into the Light" (p. 107), I began sketching the composition and carefully planned each step. I wanted a different perspective of the view inside a lighthouse. Because I wanted a certain haunted feeling and wanted to tell a story, I used artistic license. I added the boat and rough water to add interest and suggest what the lighthouse keeper and people on the boat might have felt and thought.

Enjoy pouring and playing with paint. Most of all, have a good time.

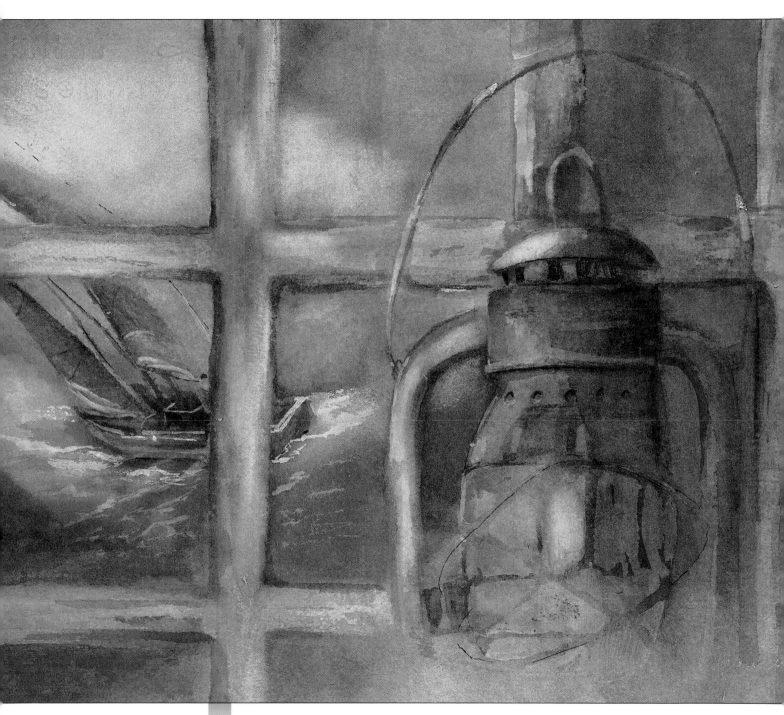

Into the Light
Marcia Moses, 16×20 inches

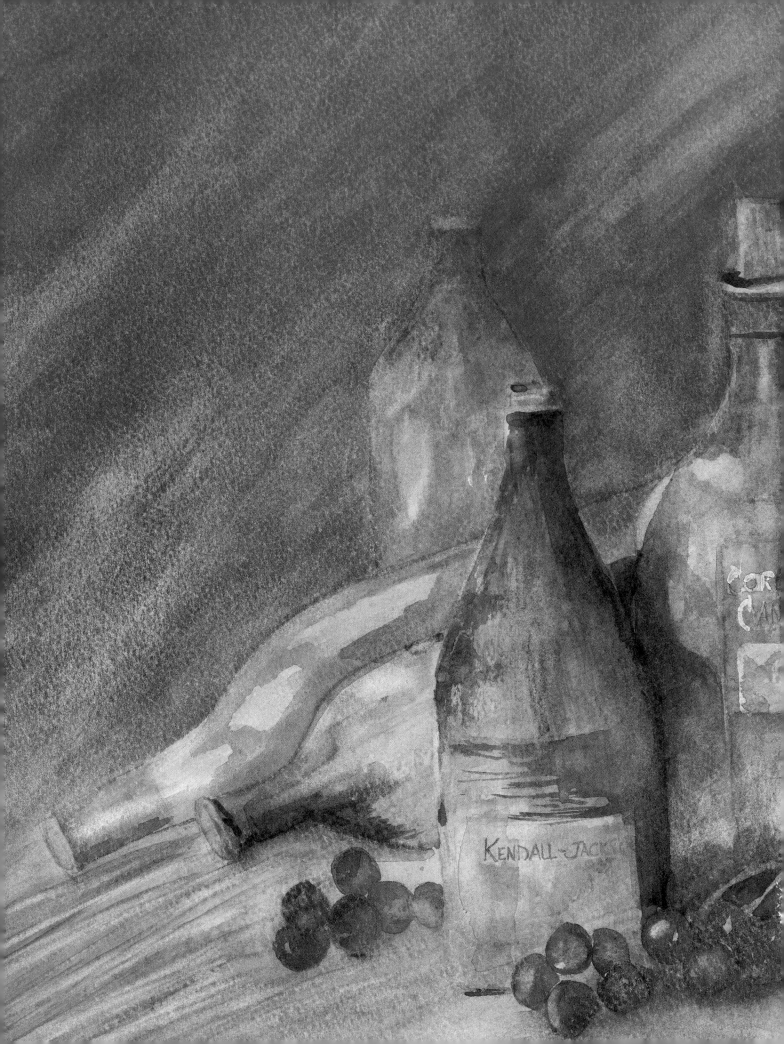

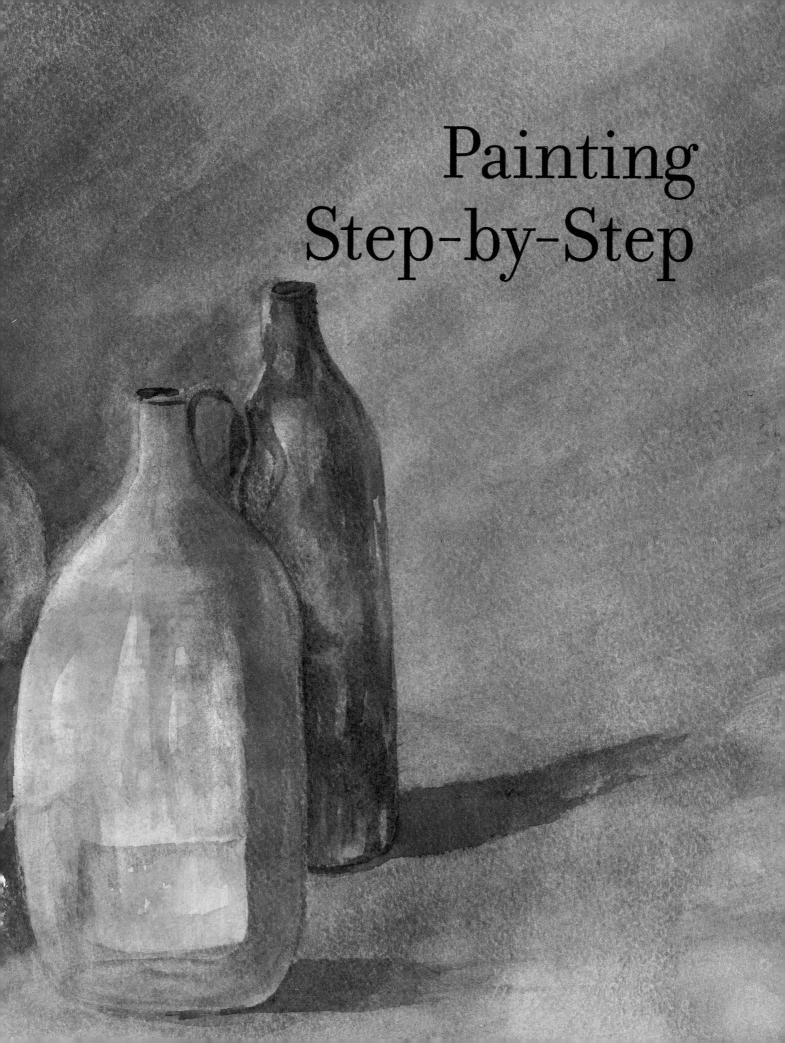

Painting
Step-by-Step

Watermelon

In most of my paintings, I use a basic palette that consists of aureolin yellow, rose madder, and cobalt blue hue. This represents the three primary colors. However, depending on the painting's needs, sometimes I develop another palette with colors that better suit my subject.

For watermelons, I wanted a palette that would give me a little more flexibility, so I chose cadmium yellow light, rose madder, and marine blue.

1. *Using a 1-inch flat brush, I painted a wash of cadmium yellow light on the entire shape of a half watermelon.*

2. *I charged this wash with marine blue, and this gave me the green I wanted for the watermelon shell.*

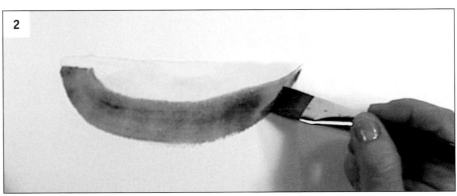

3. *With rose madder I painted a light wash inside the watermelon that began to draw out the pink of the fruit.*

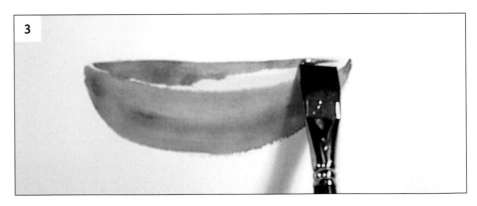

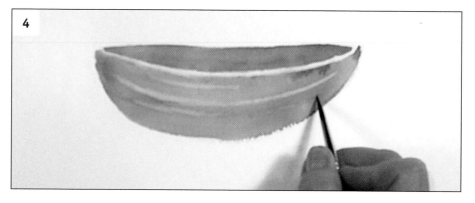

4. *With marine blue I put some darks in the shell's bottom right part to create a shadow. Then I blended this with my brush and water.*

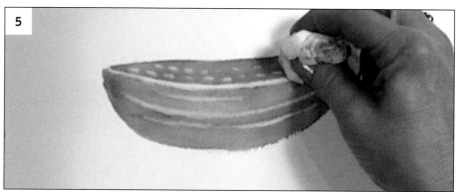

5. *With a tissue I pulled off a little rose madder and yellow to produce lights inside the watermelon.*

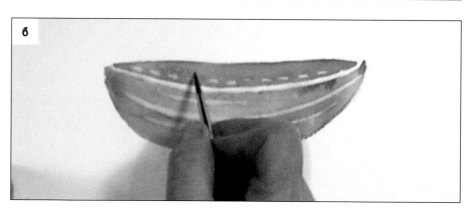

6. *I used a brush dipped in water to pull out the remaining watermelon seeds.*

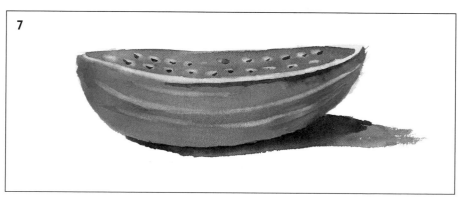

6. *With a mixture of cadmium yellow light, rose madder, and a drop of marine blue, I began final detailing. I used this color mixture for the seeds, the shadow on the surface under the watermelon, and the dark shell shapes.*

Flowers & Leaves

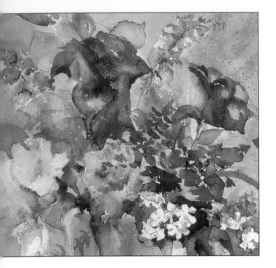

1. With a #4 round brush, wet the entire area of the leaf with water. Using aureolin yellow apply a wash on the shape.

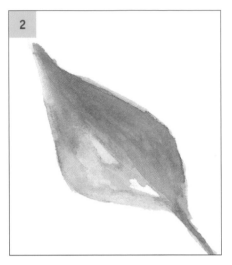

2. Immediately charge this wash with ultramarine blue, allowing the colors to mix on the paper. Use a tissue or cotton swab to lift a little color to reveal a little white shape for light. Let this wash dry.

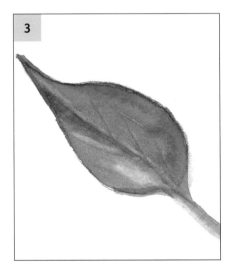

3. With a wet brush, glaze the leaf shape with a wash of aureolin yellow.

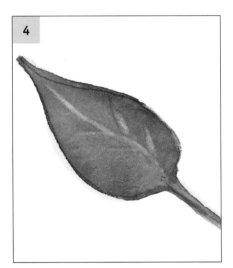

4. Apply a wash of the ultramarine blue on the dark side of the leaf, maintaining the lights previously lifted with the tissue on the opposite side.

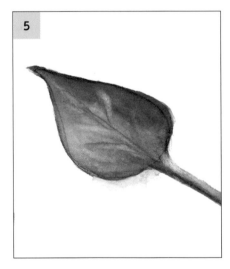

5. Finish the leaf by pulling out veins with a damp brush and tissue.

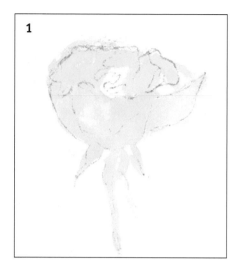

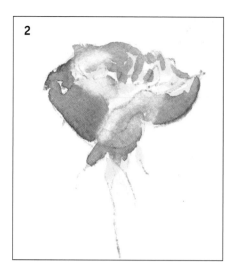

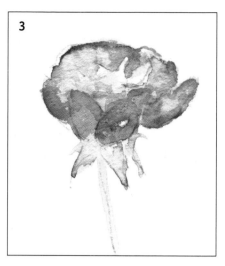

1. *Painting an open rose presents more opportunities for working with negative space since the petals create shadows between them.*

Begin by wetting the paper, leaving areas of dry paper where you want your lightest lights. Then charge the wet paper with cadmium yellow light.

2. *You want to immediately charge that wash with rose madder. It will only move in the areas that are still wet and create an orange hue to the petals.*

3. *Now you can begin putting a few dark areas where shadows will be produced. Use cobalt blue; it will gray out the orange.*

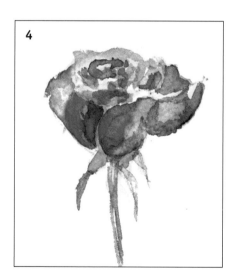

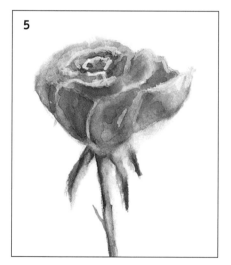

4. *After drying the work, begin to directly paint the shadowed areas with layers of cobalt blue to give the rose contrast and shape. You may also need to pull off some color with a damp brush to blend petal edges into the whites.*

5. *Layer more dark color on the rose's shadows, creating alternating warm and cool (light and dark) areas. A solid color usually results in a flat surface. Placing warm and cool colors next to each other creates dimension and life. Finish the rose with a stem and a few leaves.*

Rocks

It's great fun to paint rocks. What results from this exercise is always a surprise. And while you may not like surprises, when painting rocks you'll be able to feel your creative spirit come alive. This kind of surprise is delightful compared to, say, a houseguest who arrives without warning and plans to stay three weeks.

Ready? Get out your 1/2-inch flat brush, an old expired credit card or plastic putty knife, salt, alcohol, perfume (you'll be able to smell the texture), facial tissue, burnt sienna, indigo, ultramarine dark, water, and last but not least, a toothbrush. (Yes, use the one your unexpected houseguest left.) Let's get started!

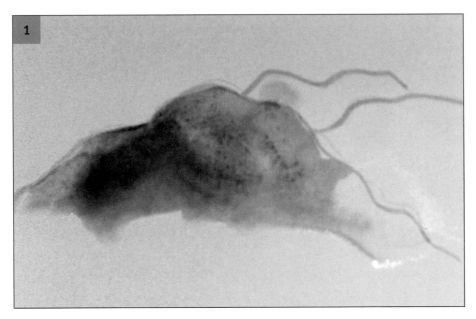

1. *Lightly sketch rock formations on your watercolor paper. I recommend Fabriano-Rosaspina or Strathmore Imperial; these papers do not have a heavy texture. That will allow you to create your own texture.*

Wet the positive areas and leave a dry white separation between the shapes.

Begin to drop color and let it flow in all directions. It doesn't matter which color you drop first.

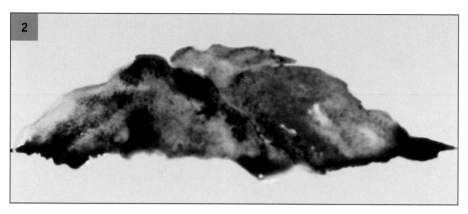

2. *Let the colors mix on the paper, and while they're still wet, use your credit card or plastic putty knife to move color around, creating shapes.*

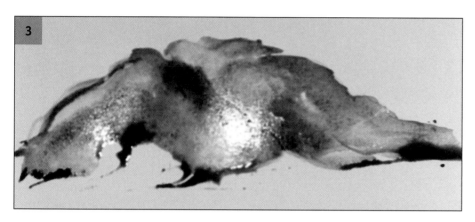

3. *With each introduction of color, you'll discover a new effect. Because ultramarine is a sedimentary color, it will create texture when mixed on paper with burnt sienna. When moving colors, make sure you place lights next to darks for the illusion of motion and drama. While the paint is still wet, spray alcohol or perfume on it and watch what happens. Sprinkle salt on spots where you want to lift paint and create texture. Paint darks in shadowed areas. Spatter both colors with a toothbrush to add more texture. Experiment with these tools, and by all means, have fun. With a crumpled tissue, lift areas you want to lighten and watch what happens.*

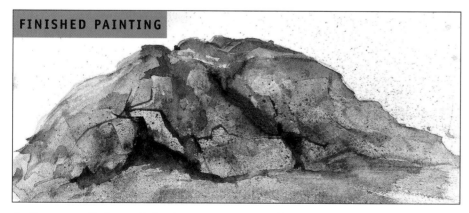

FINISHED PAINTING

4. *Lay a small sheet of plastic wrap on areas where you may want more texture. The plastic wrap will create small lines of texture.*

Magnolias

To reproduce this magnolia, I studied the flower and came to know its many beautiful shapes, colors, and values. It's much easier to paint what you know than to rush blindly into a painting without studying the subject.

1. First, I sketched the magnolia in my sketchbook using only three values. This preliminary sketch helped me decide where colors and shadow would be needed. Then on watercolor paper, with my pencil, I reproduced the bigger shapes from that initial sketch.

2. Before I began painting, I decided where color values would be darkest and lightest. Using an initial glaze of aureolin yellow, I began to paint, carefully painting around the flower shapes to preserve the whites.

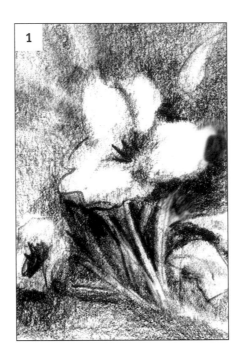
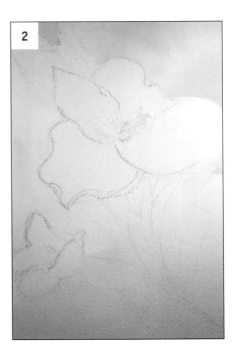

3. The initial glaze with aureolin yellow establishes the background for the larger shapes.

4. Next I introduced marine blue, a blue-green transparent color that allows the yellow glaze to show through. Marine blue is a blue with a long value range from a mild green-blue to a rich, vibrant, deep blue-green. I began with a watered-down light value of this color and glazed areas around the largest shape.

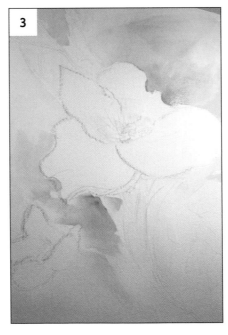
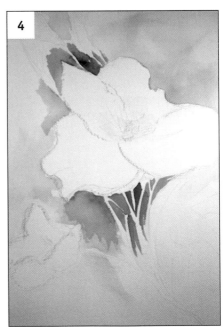

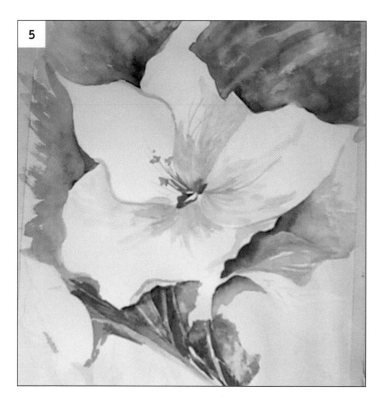

5. *I continued to glaze a second layer of the marine blue around the larger shapes, which made my blues darker. With light and dark colors next to each other, my flower began to appear three-dimensional. Then I waited for the glazes to dry.*

Next I glazed a layer of aureolin yellow around larger shapes and waited for them to dry. Then I applied a layer of marine blue. This time, however, I didn't dry them because I wanted to mix a little of the wet paint with another color on the paper. This would give the background a little texture.

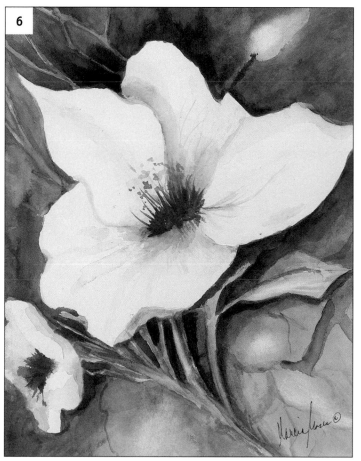

6. *With the marine blue, mixed with very little water, I began to paint details, such as the flower's center, the space between stems, and the flower's shadows.*

Then I took the marine blue in mid-value, and glazed the bottom left and top middle. While that was still wet, I glazed the bottom right and top left with aureolin. I let them dry.

At this point, I began pulling off paint with a damp brush. I clarified whites on the stem, pulled whites out of the leaves, and finished by adding details with burnt sienna on the darker side of the magnolia's stems and stamens.

Glass Jars

Many artists shy away from painting glass because they believe it's too difficult to capture its transparent qualities.

What they need to do is to look inside the glass. The objects inside those glass jars have distinct shapes. The jars in this demonstration contain pickles, tomatoes, and pears.

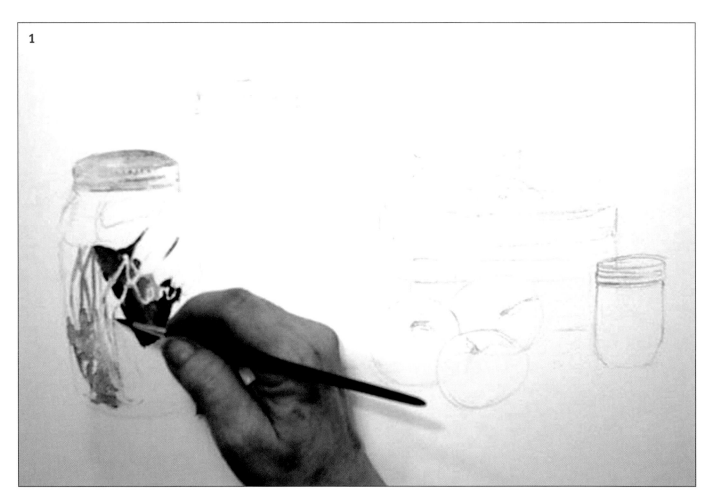

1. *I begin with the pickle jar by using negative painting to establish dark shapes behind the pickles; these shapes will help distinguish the pickles. I also use a layering technique, first putting on a layer of cadmium yellow light (which is a transparent yellow). Then I add a layer of cobalt blue hue. That will make green.*

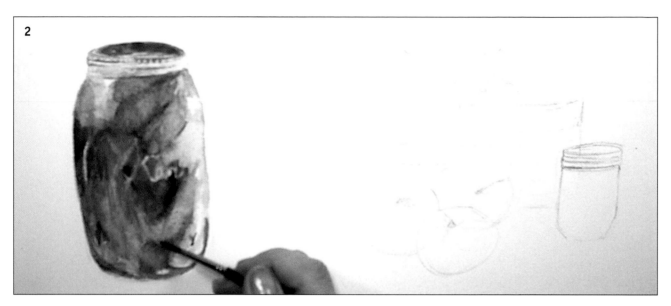

2. *Then I add a layer of rose madder and repeat the entire process until I've established the appropriate shade of green. I keep in mind that I also need to paint around my white shapes, which are reflections of light nearly always seen in glass. When painting glass, leave soft edges on shapes that are reflections. I did that by using a wet brush to cause different colors to blend with each other or with the light areas of the reflections.*

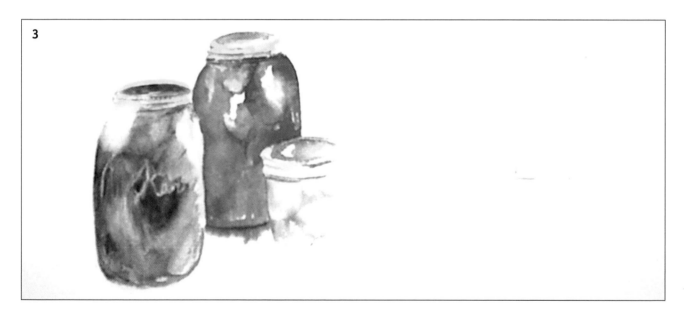

3. *For the jar of tomatoes, I first applied a layer of cadmium yellow and then a layer of rose madder. This created orange. Then I had to pull out shapes.*

After the paint was dry, I mixed the same two colors on my palette, and I added the complement, which was blue. This darkened my paint to a color I needed to begin negative painting to make the tomatoes come forward. While the paint was still wet, I used a tissue to lift some color, creating reflections in the jar. I could have used this method with the pickle jar, too. It would have been easier, but there were so many shapes in the pickle jar that I was afraid I'd miss some of them.

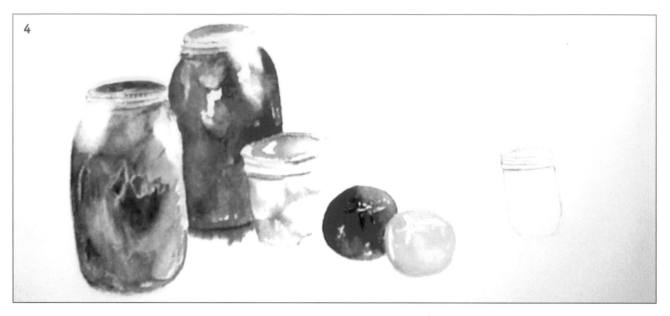

4. *I created the jar of pears in much the same way as the jar of tomatoes, but I applied a thinner layer of cadmium yellow. Then I applied a thin layer of rose madder on top of that, which created a pear color.*

I painted the whole tomatoes by beginning with a layer of cadmium yellow light, and then immediately applied a layer of rose madder. Finally, I dropped in cobalt blue around the shadowed areas. Then I simply lifted the color with a tissue to again create highlights on the tomato skins.

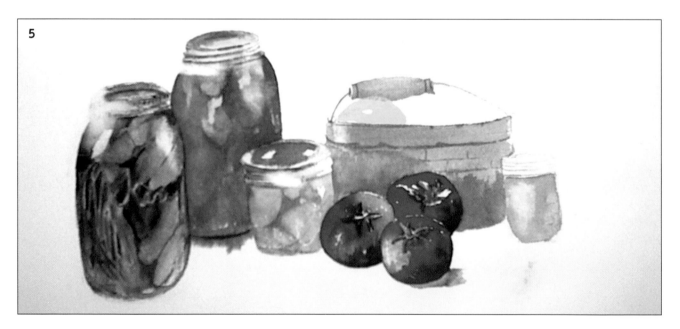

5. *For the jar lids, I started with cadmium yellow and painted all areas where light would reflect off them. Then I mixed cadmium yellow light, rose madder, and a drop of cobalt blue on my palette. This gave me a burnt sienna, one that's more reflective than using burnt sienna from a tube.*

For the basket, I used a layer of cadmium yellow, then immediately a layer of rose madder, and a thin layer of cobalt blue. Then I came back in with another thin layer of cadmium yellow. I created the small jar of unidentified light green vegetables (green tomato relish?) at the right with a layer of cadmium yellow and then a layer of cobalt blue.

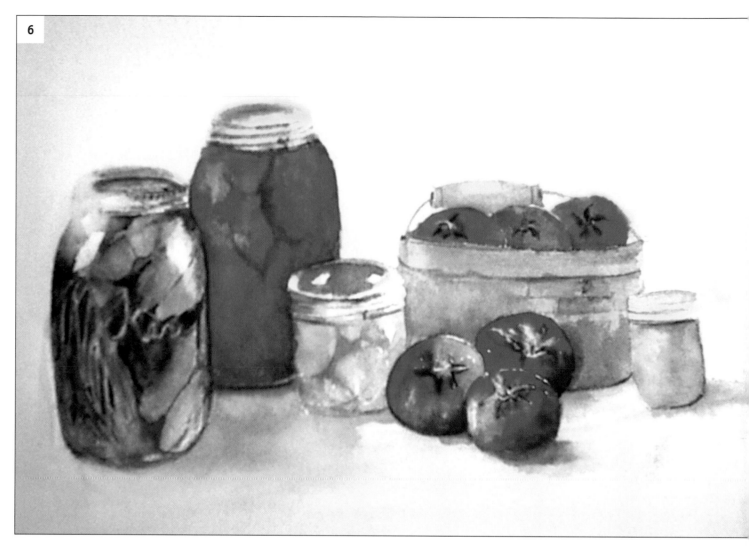

6. *After everything was dry, I did the detail work. For the darks on the jar lids, I used the same mixture I had used to get burnt sienna. I also used it for negative painting in the jar of pears.*

To get some warmth into the background, I layered all three colors, beginning with cadmium yellow, adding rose madder next, and finishing with cobalt blue. This achieved a blended background that created unity and balance.

Finally, I used cobalt blue to create shadows. Shadows are what give a painting life. They add depth. They give your objects perspective, a place to rest, so that they are not floating in air.

Note that I've only used three colors through this entire process. All of them are transparent colors, which give the painting a clean look. When you mix colors that aren't transparent, you'll sometimes create a muddy appearance.

Little Boy

Figures can be the most exciting element in a painting, both visually and emotionally. They add dynamism to an otherwise static scene. When you place a figure in a painting, it naturally becomes more interesting. The viewer begins to ask himself questions about the scene. What is that figure doing and why?

In the painting "Guilty," I wanted to draw a child who would capture the viewer's heart. I believe he does.

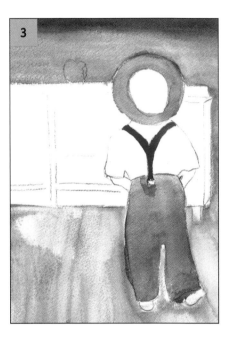

1. *I began this painting with a value sketch in my sketchbook. Experimenting, I decided that my center of interest should be in the lower right hot spot on my grid and that my lights and darks (values) would create movement and tension.*

2. *After completing the value sketch, I re-sketched the painting on watercolor paper, lightly so that I didn't damage the paper. I used aureolin yellow to begin background glazing. With the yellow paint, I painted around the large shapes, the boy and the desk, and established basics for the background. To create a warm background around my main figure, I next used alizarin crimson to glaze the same area.*

3. *I added another glaze of aureolin yellow and then charged that glaze with alizarin.*

With these glazes, I attempted to create a uniform warm color behind my subject so that when I put my darker transparent colors over them I would still get the glow from the initial glazes.

These background glazes also began to make individual objects in the painting more apparent. They outlined the shapes and began to bring them forward. This set up the shapes for detail work.

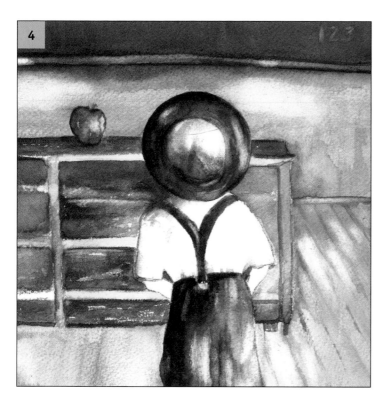

4. *First I applied glazes, in this order: aureolin, alizarin, and cobalt blue. I layered these colors at least six times on the teacher's desk and even more on the blackboard. The more you glaze, the darker the color will become. I wanted the desk to appear old and oaken and the blackboard to look like the gray, slate chalkboards once used in grade schools.*

Next I began painting the little boy's clothing. I used a mixture of aureolin and alizarin, charging that mix with cobalt blue to achieve a dark hue. I painted the darks in the hat, pants, and suspenders with a couple layers of this color and left my lighter areas of the garments white until my wash dried. At that point, I applied one layer of the color to light areas to create the clothing's highlights.

The shirt I left completely white until the rest of the boy's outfit was finished. Then I applied a single layer of shadow colors, using the same mixture of paints as for the dark areas, but with more water.

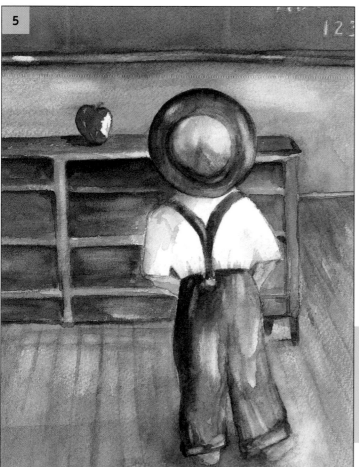

5. *The apple was painted with a mixture of aureolin yellow and alizarin. The apple's dark shadows were made with a mix of aureolin and cobalt blue.*

To finish the painting, I applied a layer of cobalt to create shadows from the figure and desk. I created the texture and outline of the floorboards by using a mixture of aureolin and alizarin, with a touch of cobalt.

I finished off the boy's arms and feet, creating skin tones using a mixture of aureolin, rose madder, and cobalt blue.

Notice the writing on the blackboard. I pulled out the letters and numbers with a damp brush. I used the same technique to pull out the white of the chalk in the blackboard tray.

Glazed Bottles

1. *After sketching the bottles, I apply thin coats of paint around the objects, creating a background. I began with aureolin yellow and allowed this to dry so that my next glaze would not pick up the aureolin.*

2. *Next I applied a glaze of alizarin crimson. Keep in mind that if you want to preserve any lights, you need to do it in these early stages. I wanted the top right area to be lighter, so I didn't glaze over it.*

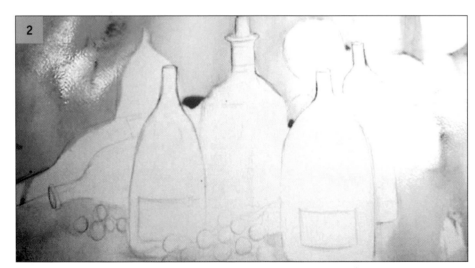

3. *Notice the darker paint colors in the left half of the background. If paint is too wet, it will gather in pockets. If you want to create a textured background, this could work to your advantage.*

I didn't, so I merely collected that darker paint with the edge of a tissue.

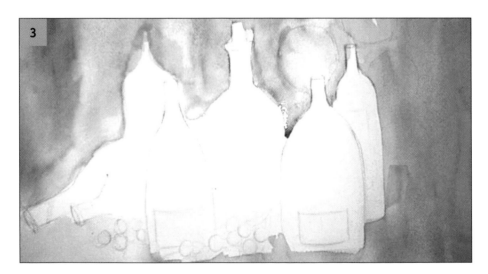

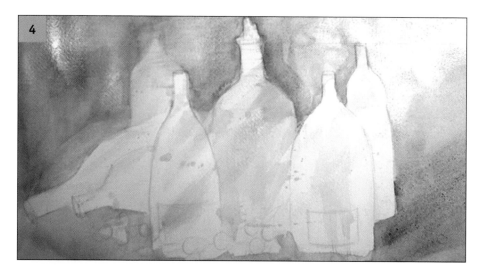

4. To tone things down, I added another transparent color, a glaze of ultramarine dark. I needed to be careful not to add too much blue to the already orange tone, which would cause a muddy or dull appearance. By applying only a thin glaze of blue, I also preserved the painting's luminosity.

While adding the blue glaze, I decided to bring a little blue into my objects. I pulled the brush inside the bottle outlines.

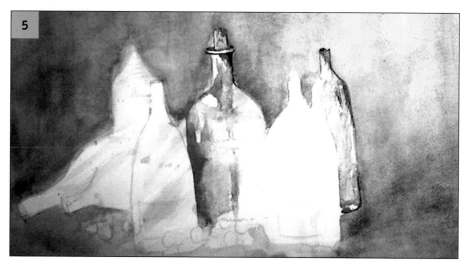

5. I began adding details to objects between glazes. Sometimes I try to work in another area of a painting while the glaze dries naturally. Blow-drying the glaze could sometimes move the paint in an undesirable way.

After glazing numerous times, alternating using the three primary colors to create a unified effect, I did a little spattering to create texture on the bottles. For spattering, I used a toothbrush, dipping the bristles into ultramarine blue and using my thumb on the brush to spatter the color lightly.

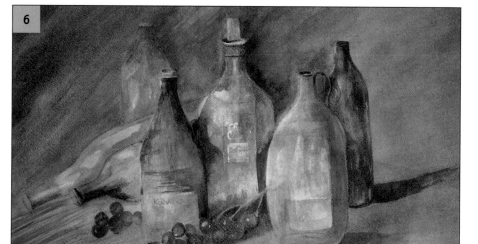

6. I directly applied ultramarine blue for shadows.

In the end, I wanted the painting to look old and the bottles to look as though they had been sitting in a wine cellar for decades. For aging, I used a blue glaze over all but my lights. This softened bottle edges and shadows and gave the painting a more subtle appearance.

After a little more detailing, such as lifting paint off the lights in the grapes in the foreground, I was finished.

Street Scene in France

For "Street Scene in France," I poured paint rather than brushed it on. I could have gotten luminous colors with brushwork, but pouring gave me the glow I wanted.

1. *First I established lights and darks with a value sketch. Then I began this painting by masking off my light values with masking fluid to preserve them during the pouring process.*

Because I wanted the painting to have a luminous appearance, I decided to first pour cadmium yellow. Using a small paper cup with paint inside, I poured the color all over the paper and spread it around with water mist from a spray bottle. This meant that I did not need to touch the paper with a brush, which would have given the pouring a less smooth appearance.

2. *When I felt that the yellow paint had saturated the paper, I began to pour the rose madder. I let the two colors merge on the paper.*

I sprayed the paint with water to move it around, causing it to spread over all the unmasked portions of the paper. I also tilted the board and moved it around to merge the colors further.

3. *Next I poured cobalt blue hue selectively in places on the painting where I wanted dark values. I let this color settle into the painting for a few minutes before pouring the color off.*

4. *After pouring off excess paint, I placed the painting on an easel to dry. I used a brush on the painting's edges to soak up excess paint and water so that I wouldn't get water spots, called blossoms.*

Note that the painting is lying on its side. I wanted to maintain the blue in the sky area. If I had turned the painting in any other direction on the easel during drying, that blue color would have been damaged by adjacent colors running into it.

Also notice the masked areas near the painting's bottom as it sits on the easel. These areas look like rocks, but these light areas that the mask protects will eventually become an area of walls in the street scene.

5. *If you find that your first pourings are too weak, after the first colors dry repeat the process until you get the desired colors. It's critical that you wait until the colors have dried completely before a second pouring. Otherwise, your painting will become muddy.*

In this painting, I didn't feel another pouring was necessary, so I began detail work with my light areas. I removed the mask with a soft eraser and began to add layers of cadmium yellow light and rose madder in areas I wanted to keep warm and vibrant. Since the arch was my center of interest, I chose to use bright colors to pull the eye in that direction.

I distinguished between buildings by using light and dark values alternately. If each wall were the same value, everything would look the same.

I used a mixture of cadmium yellow light and rose madder to create the light reflecting off a roof visible beneath and beyond the arch.

Having established the buildings' contours, I needed to add detail to give the buildings dimension and make them come alive.

6. *(Opposite) First I painted in the chimney for the center building and added steps to the structure in the right foreground. I put plants on the walls of that right building and a railing beside its steps. I painted in a door in that building. In the far right foreground, I created a stone wall by painting cobalt blue hue over the orange tone to gray them.*

After completing more detail, I added a wash of cadmium yellow light over everything in the painting except the sky. Then I applied a thin wash of rose madder to brighten the painting and bring the colors to life.

An Artist's Gallery

Winter Thaw
Marcia Moses, 22×30 inches

My Sailor
Marcia Moses
11 × 14 inches

Apple Basket
Marcia Moses, 7¾ × 10¾ inches

Apples
Marcia Moses, 8 × 10 inches

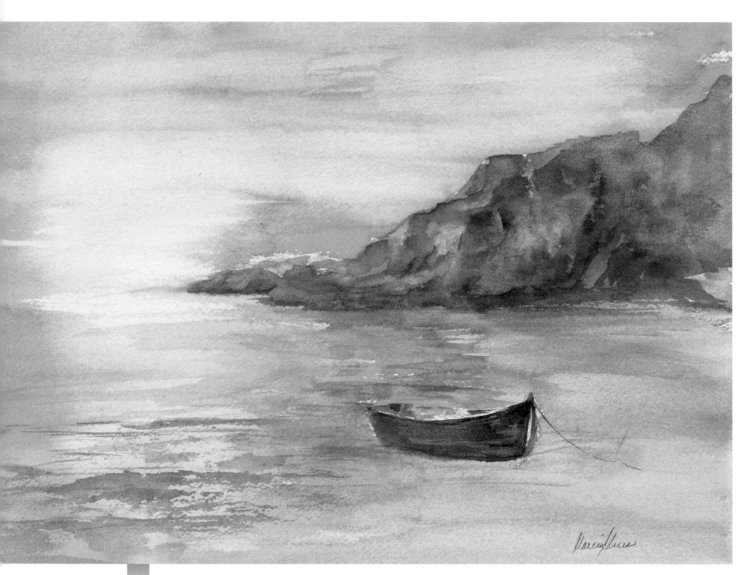

Lonely Boat
Marcia Moses, 11×14 inches

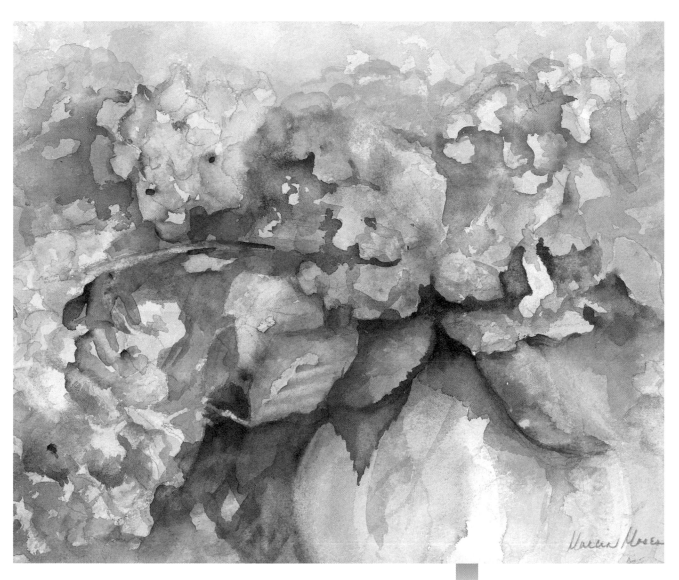

Hydrangeas
Marcia Moses, 11 × 14 inches

The Vineyard
Marcia Moses, 18 × 24 inches

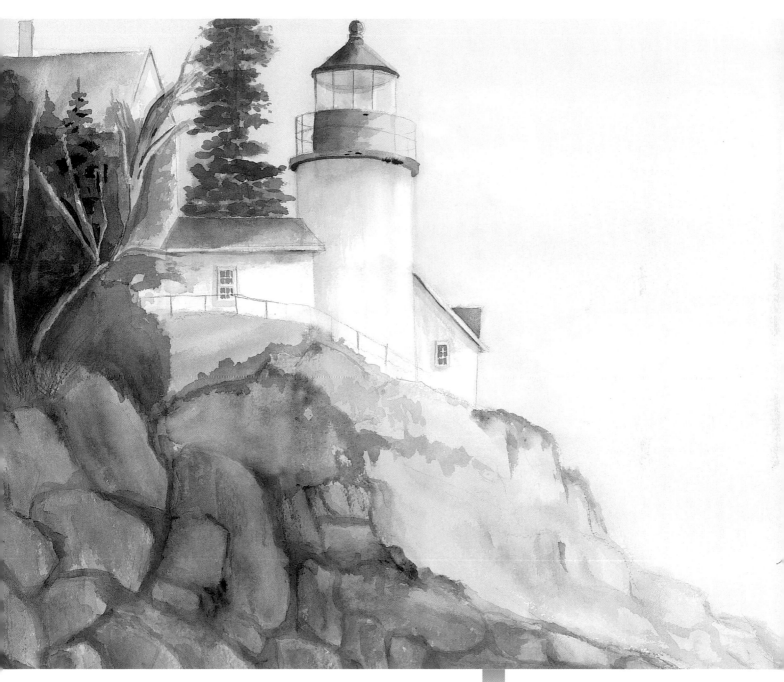

Bass Harbor
Marcia Moses, 22 × 30 inches

Oily Situation
Marcia Moses, 16 × 20 inches

Pat's Chair
Marcia Moses, 16 × 20 inches

Water Bearers
Marcia Moses, 11×15 inches

Marblehead Winter
Marcia Moses, 11×14 inches

Pebble Beach
Marcia Moses, 15 × 30 inches

Fish Beach
Marcia Moses, 16×20 inches

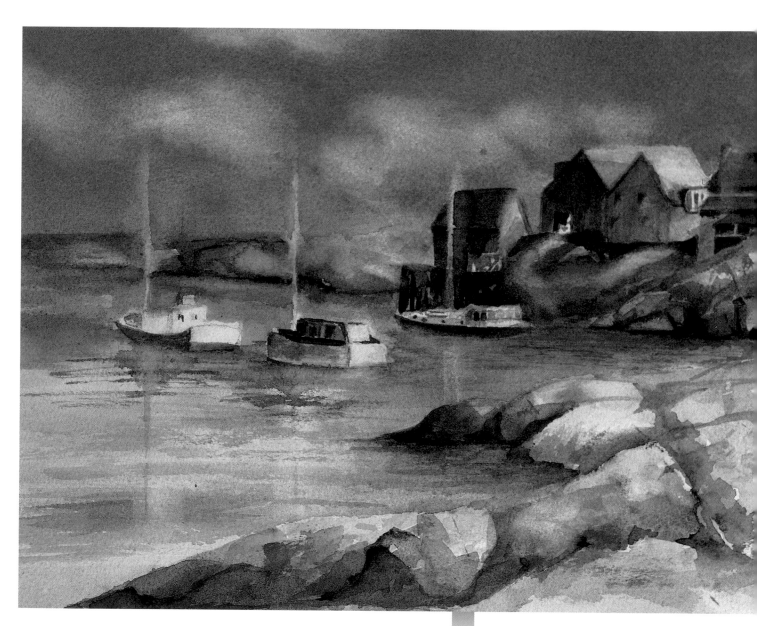

Monhegan View
Marcia Moses, 18×24 inches

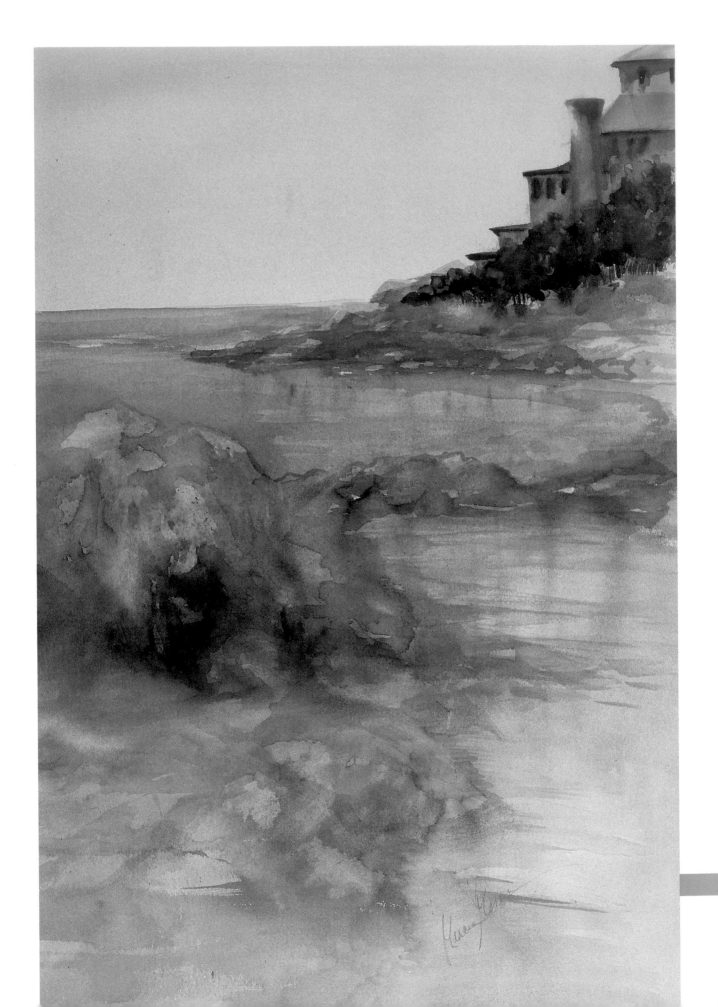

Vessels of Antiquity
Marcia Moses, 22 × 30 inches

Gloucester House
Marcia Moses, 22 × 30 inches

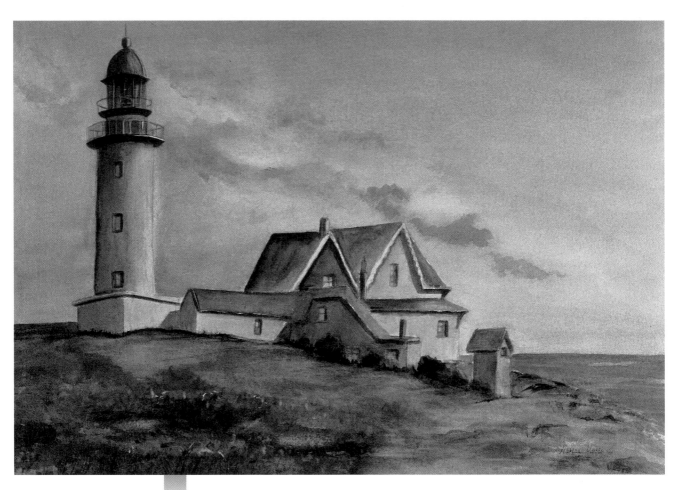

Cape Elizabeth
Marcia Moses, 22×30 inches

Acknowledgments

First and foremost, I want to thank Fred, my husband, for being there through good times and bad. Without his support, I wouldn't be the person I am today. Thank you, Fred, for pushing me to finish this book.

I also thank my wonderful three children and their terrific spouses, Fred and Stephanie Moses, Erik and Angela Parker, and John and Leanne Moses for being the joy of my life. My beautiful grandchildren, Hayden, Haley, Tyler, Aiden, and Ireland spark my creative fire. My thirteen foster children taught me to give; I'll always love them wherever they are.

My brothers, Jim and John Swartz, have taught me how to grow. My sister Mary has always given me the best hugs, and Joan has taught me to forgive.

Bill and Gail Moses, my family through marriage, helped smooth my journey on what could have been a bumpy road. From the bottom of my heart, thank you for your love, believing in me, and realizing what I could become.

Christa, Joe, and Adam Rich, loved me when I made loving me difficult. Uncle Red and Aunt Lou, gave me a mother and father's love. Mary Nieto, sister through fate and a wonderful friend, has given me constant, unconditional support.

Many friends have encouraged my art and writing: Pat and Tim Speelman, Nina and Jerry Kisela, Patty and Gary Bagueros, Pete and Sandy Fusillo, John and Marie DeLibera, Joe and Phyllis Amato, Whitney Thompson, Jim Penland, and Molly and Ed Allar, Toni and Mark McKelley, Dave and Shella Marzich.

In my life, I've been blessed with special people, like Nancy Fraga and Tommy and Peggy Caito, who have truly made a difference. I thank God for my wonderful friend and brother through fate, Bob Delano. Please keep painting.

To all my teachers, especially Maurice Oatley, for giving my art and life direction. All my students have taught me more than I could ever teach them. Watching them grow has encouraged my own growth. Thank you.

Jeanette Green, my editor, has had the most recent significant influence on my growth as a writer. Thank you for keen editorial insights and for being such a dear newfound friend.

Gary Brown, my second set of eyes, helped develop this book. For nearly three years, he put up with my moods, encouraged me to write, shared his passion about writing, and buoyed my spirits when I was down. He remains a great friend. Gary, thank you doesn't seem to be enough for the faith you have had in me.

Many artists, including Tom Lynch, Paul George, Wanda Montgomery, Len Garon, William Persa, Diana Loomans, and Alex Alampi, Jr., have shared their work and made my book better by their participation.

I also gratefully acknowledge Canson-Talens (Kevin and Susie Kelley), The Color Wheel Company (Ken Haines), Grafix Art (Debra Paden), HK Holbein (Tim Hopper), Strathmore paper (Donald Bozek), Speedball Art Products (Tanya Hill), Robert E. Woods palette (Jack Richeson) for use of images of their products. I also want to thank Jordi Falgas at Fundacio Gala-Salvador Dali Foundation for her permission to use Salvador Dali's "50 Secrets of Magic Craftsmanship."

—Marcia Moses

Glossary

ALCOHOL Isopropyl alcohol, applied to a cotton swab, can be used to lift out paint, or it can be sprayed on a designated area to lift out paint. Be careful: it can create gray spots on paper that you will not be able to remove.

ALTERNATION Creating a pleasing variety or mix of things in a painting. Contributes, with repetition, to the rhythm of a painting.

ANALOGOUS COLOR SCHEME Composition using closely related colors.

ANALOGOUS COLORS Colors near each other or closely related on the color spectrum, especially those with common hues.

BALANCE Aesthetically pleasing integration of elements in a painting; the relative weight given objects or areas of a painting. Conflicting elements need to be brought into visual balance. Often asymmetry works best and is most pleasing.

BLENDING (1) Smoothing the edges of two colors so that they have a smooth gradation where they meet. Watercolor washes will dry with hard edges, unless you work on dampened paper. (2) Mixing two or more paints.

BRISTLES The hairs on a brush used for painting. Soft and stiff bristles made of sable, Kolinsky sable, hog, goat, ox, squirrel, wolf, synthetic, and combination hairs are available.

BRUSH A watercolor brush consists of a handle, ferrule, and bristles. When buying brushes be sure that the hairs are firmly attached inside the ferrule and that there are no splayed or loose hairs. The brush should point or edge well and return to its original shape quickly. The belly of the bristles should hold a lot of color and release paint slowly and evenly. Brushes come in a variety of shapes and sizes: round, spotter, rigger, mops, wash, flats, and Asian.

BUTCHER'S TRAY An open palette used for watercolor that doesn't have wells for paint.

CHARGING Applying a first color to paper with a brush and then applying a second color into the wet paint of the previous color.

COLD-PRESSED PAPER This paper variety (CP) is also called NOT, which means it was not made by the hot-pressed process. It has an open or coarse texture. Hot-pressed (HP) paper is smooth and does not have as much texture.

COLOR Produced when light strikes an object and then reflects back to our eyes. An element of art with three properties: (1) hue or tint, the color name, e.g., red, yellow, blue, etc.: (2) intensity, the purity and strength of a color, e.g., bright red or dull red; and (3) value, the lightness or darkness of a color. *Also see* pigment.

COLOR WHEEL A radial diagram of colors in which primary and secondary, and sometimes intermediate colors are displayed as an aid to color identification, choosing, and mixing.

COMPLEMENTARY COLOR SCHEME Using two colors opposite each other on the color wheel in your composition, such as red and green.

COMPLEMENTARY COLORS Hues directly opposite one another on the color wheel. When placed side by side, complementary colors are intensified; when mixed together, they produce neutral colors or a range of grays. When mixed full strength, they produce dark gray or brown.

COMPOSITION The organization, design, or placement of individual elements in a work of art. How the unity, harmony, balance, rhythm, contrast, dominance, and gradation work within a

painting. The term composition is often used interchangeably with the term design. Composition means the total content of an artwork; design means the arrangement of its elements, layout or plan.

CONFLICT This occurs when seemingly opposing ideas are introduced. While conflict draws interest, if it remains unresolved, we may be dissatisfied with the painting. Resolve conflict by using dominance; emphasize a particular shape, color, or line.

CONTRAST The play of light against dark, warm against cool, and soft against hard, etc. elements or figures in a painting.

CONTENT The subject matter or motif of a work of art.

CONTOUR A line which creates a boundary separating an area of space or object from the space around it.

CONTROLLED DRIP The process of applying paint to an already wet surface, allowing the paint to flow into the water.

COOL COLORS Colors with a blue undertone or blue bias.

DESIGN The planned organization of line, shape, color, texture, direction, value, and space in a work of art. The seven principles of design are unity, harmony, balance, rhythm, contrast, dominance, gradation. Design also refers to the arrangement of elements, the layout or plan of an artwork.

DOMINANCE The center of interest or focal point. The principle of visual organization which suggests that certain elements should assume more importance than others in the same composition. With conflicting shapes or ideas, resolve the conflict by emphasizing one or the other; allow it to dominate.

DRY BRUSH A painting technique in which, as the name suggests, a little bit of paint is put on a dry brush. When applied, it produces a broken, scratchy effect.

DRY ON DRY A watercolor technique of applying paint with a dry brush on dry paper.

DRY ON WET A watercolor technique using a dry brush loaded with paint applied to wet paper.

EASEL A structure designed to hold an artist's paper or canvas. Many have vertically adjustable sliding trays and most fold for easy storage.

ELEMENTS OF DESIGN The basic components used by the artist when producing works of art. Those elements are color, value, line, shape, form, texture, and space.

EYES A painting's hot spots, where the center of interest should be placed. *See* hot spots *and* the rule of thirds.

FERRULE The metal cylinder that surrounds and encloses the hairs on a brush.

FORGIVING Describes paint that can be easily lifted from paper or smooth paper that allows paint to be easily lifted from it.

FORM The physical appearance of a work of art; its materials, style, and composition.

GLAZING A very thin, transparent paint applied over a previously painted surface that has dried. You'll be able to see the various glazes beneath the other colors. If you use opaque colors, the results can be muddy. For glazing, you need to use transparent colors.

GOLDEN SECTION Based on the ratio between two unequal parts of a whole when the proportion of the smaller to the larger is equal to that of the larger to the whole. Ideal proportions of a rectangle are determined by the golden section. The longer side is equal in length to the diagonal of a square whose side is equal to the shorter side of the rectangle. This ratio works out to 0.618 to 1 or about 5 to 8. In a rectangle drawn or constructed according to the golden section, the width should be 0.618 of the length.

GRADATED WASH A wash that is light or thin in an area where little color has been applied and gradually becomes darker or heavier into another area, where more color has been applied. This is sometimes also called a graded wash.

GRADATION A gradual, smooth, step-by-step transition or change from dark to light values or from large to small shapes, or rough to smooth textures, or one color to another.

GRAY SCALE The range of neutral values or shades of gray.

GRID A series of horizontal and vertical lines marked off evenly on paper or on a picture to aid in drawing the picture and to locate centers of interest. *Also see* hot spots *and* rule of thirds.

HARMONY The unity of all the visual elements of a composition achieved by repetition of the same shapes, colors, or other characteristics. Close association of objects or design elements in a picture.

HOT-PRESSED PAPER Hot-pressed (HP) paper is smoother than cold-pressed paper with less texture and, therefore, less sparkle and brilliance.

HOT SPOTS Where important objects or images in a painting should be placed. These are areas of more than usual interest, activity, or action in a painting. Divide a rectangle into thirds horizontally and vertically to create nine smaller rectangles. The four points where grid lines intersect one another are called the "eyes" or hot spots, suitable to place the painting's center of interest. *Also see* the rule of thirds.

HUE The color of a pigment or object. A gradation or attribute of color that permits colors to be classed as red, yellow, green, blue, or an intermediate between any contiguous color pair.

INTENSITY The degree of purity or brilliance of a color.

KOLINSKY SABLE Fur of the Siberian sable (a mammal related to the weasel); these hairs are used for the finest sable brushes. Now rare, many brushes not actually made from the Siberian mammal go by this name.

LAYERING Applying additional color to paint that's still wet. Layered colors are usually transparent. Glazing is usually done with wet paint on already dry paint.

LIFTING OUT PAINT Pulling off or out paint helps reveal whites (often of the original paper) or texture and can create soft-edged effects. You can lift out wet or dry paint, although the latter may require more effort and can be coaxed with a small amount of gum arabic. When added to paint water, gum arabic will give your paint extra body, and it will be easier to lift out when dry. A sponge and clean water can lift out paint. Let the paper dry before repainting or continuing with another effect. Use a small cotton swab or scrape with a craft knife.

LINE A mark made by an instrument as it is drawn across a surface.

LOADING the BRUSH Wetting the brush with water and dipping the bristles into paint.

LOCAL COLOR The actual color of an object being painted, unmodified by light or shadow. (Grass is green.)

MASKING FLUID A quick-drying liquid latex gum product used to cover a surface on a painting to protect it from receiving broad washes of paint. Many brands are available. When finished, remove the masking fluid by rubbing it off with a fingertip or an eraser.

MONOCHROMATIC Having one color or hue; light and dark shades of a single color plus white.

MONOCHROMATIC COLOR SCHEME Using a single color in a composition in a range of values.

NEGATIVE PAINTING Painting in areas surrounding objects to which you want to draw attention. This requires planning.

NEGATIVE SPACE The space in a painting around the objects depicted.

OPAQUE PAINT Does not allow layers of color beneath it to show through.

PALETTE (1) The mixing surface used for paints; watercolor palettes come in a wide variety and have recesses or wells for containing paint. They're made of white ceramic, enameled metal, or plastic. Tinting saucers, palette trays, and integral palettes in enameled-metal paint boxes are available. Paint boxes are useful when painting outdoors. A collection of small white cups and dishes

can make improvised or makeshift palettes. Two recommended palettes are the butcher's palette or the Robert E. Wood palette. (2) The selection of colors an artist chooses to work with.

PAINT GRADES These are artists' (first quality) or students' (second quality). Student-grade watercolors lack the subtlety and transparency of first-quality paints. Although artists' quality paints are more expensive, they're worth it. Students' paints may, however, produce brighter color than you could achieve using artists' paints. However, colors may not be as permanent if exposed to window light.

PAINTS Watercolor paints consist of very finely ground pigments bound with gum-arabic solution which enables the paint to be heavily diluted with water to create thin, transparent washes of color without losing adhesion to the support. Some paints have glycerine or ox gall added; it's best to avoid those for watercolor. Watercolor paints come in two basic types, pan paints and tube paints. Pan paint can be purchased pre-poured in pans or half pans as well as in a small, covered palette. Tube paints or pigments are usually more expensive and of higher quality. They come in sealed tubes from which you can squeeze out a little paint onto your palette.

PAN-AND-CAKE PAINTS Watercolor pigments are available in pans and half pans (small compressed blocks of color) or small cakes that neatly fit into enamel-metal boxes with recesses or wells that hold them in place and separate them. Color is released by stroking the paint with a wet brush. The wetter the brush, the lighter the tone. Pans are easy to use when painting outdoors and can stay in position in the box. They don't leak and help you avoid wasting paint.

PAPER WEIGHT The thickness of a sheet of paper, as expressed in pounds, relative to a ream, or 500 sheets. For example, 500 sheets of 140-pound paper weigh 140 pounds.

PERSPECTIVE Representing three-dimensional volumes and space in two dimensions in a manner that imitates depth, height, and width as seen with the eyes.

PIGMENT A coloring substance made from plants, earth, or minerals and other or synthetic pigments. Paints with the same color name can vary markedly from brand to brand because of the different formulation or mixture of pigments.

POSITIVE SPACE The space in a painting occupied by the object depicted (not the spaces in-between objects).

POURING A painting technique that involves pouring diluted paint from a cup or bottle directly onto paper.

PRIMARY COLORS Any hue that, in theory, cannot be created by a mixture of any other hues. Varying combinations of the primary hues can be used to create all the other hues of the spectrum. In pigment the primaries are red, yellow, and blue.

REPETITION Recurring themes in an artwork; repeated sizes, shapes, line directions, and more contribute to a picture's unity.

RHYTHM The variety (say, alternation) and repetition of design elements create rhythm in a work of art.

RULE OF THIRDS A simple method for finding hot spots in a painting or photo. Divide the rectangle of the painting or photo into thirds horizontally and vertically, to make nine smaller rectangles. At the four points where the grid lines intersect one another are the hot points or "eyes" of the painting where one could place the painting's center of interest.

SCRAPING Use the angled end of your brush, a piece of an old credit card, or even a razor blade to scrape paint off the surface of your paper. This needs to be done on a damp, not wet (shiny), wash.

SCRATCHING Use the end of your paintbrush, a nail, a paper clip or any other hard object to scratch (make a groove or dent in) your paper while the wash is still quite wet. The pigment will settle in the scratches, drying darker, and giving you interesting textured passages.

SECONDARY COLORS A hue created by combining two primary colors, such as yellow and blue mixed together yield green. In pigment the secondary colors are orange, green, and violet.

SHAPE A two-dimensional area having identifiable boundaries, created by lines, color, or value changes, or some combination of these.

SPACE In painting, space may by defined as the distances between shapes on a flat surface and the illusion of three-dimensions on a two-dimensional surface.

SPATTERING Loading paint onto a brush, and then tapping the handle of that brush on the handle of another brush or your wrist, allowing the paint to spray onto the paper. This helps create texture in a painting; it can also be purely decorative. A dry brush, sponge, and an old toothbrush make useful tools for spattering. Mask with tracing paper those parts of the painting that you don't want to be spattered.

SPONGE Natural or synthetic sponges are useful tools for creating a mottled effect of texture in paint and for broad spattering effects. Control the amount of paint put on by simply squeezing the sponge slightly where you want a drier application. It doesn't allow you to create fine lines or crisp edges. You'll want to use brushes for definition.

SPRITZING Using a spray bottle to apply water or paint.

STAMPING Using a pre-cut stamp, with paint applied, to imprint an image on paper.

SUPPORTS Hard backing used to support watercolor paper.

SYNTHETIC BRISTLES Type of brush bristles using manufactured (synthetic) hair. These bristles offer greater tension than sable-hair brushes but not the water- or paint-holding capacity. Synthetic-bristle brushes are used for lifting or removing paint from paper in watercolor.

TECHNIQUE Any method of working with materials to create an art object.

TERTIARY COLORS Six colors positioned between the primary and secondary colors on the color wheel.

TEXTURE The surface or tactile quality of an object—its smoothness, roughness, softness, etc.—and trying to recreate this appearance in paint.

THROWING PAINT Loading a brush with paint, standing back, and flicking the brush toward the paper, thereby allowing the color to be applied in a random pattern.

TINT A color to which white has been added. For example, white added to green makes a lighter green tint. In watercolor, in order to make a lighter green tint, you add water.

TONE A color's lightness or darkness; a shade or tint of color.

TRANSLUCENT PAINT Allows light and other paint colors, to pass through and be seen.

TRANSPARENT Allows light to pass through so that objects can be clearly seen on the other side.

TRIAD COLOR SCHEME Using three colors that are compatible, in various values, in your composition.

TUBE PAINTS Tube colors are fairly easy to manage when mixing large amounts of paint. However, they can cause more waste because you may squeeze out more than you need from the tube. Be sure to clean the cap and tube thread before replacing the cap to prevent it from sticking. You can squeeze some paint from a tube into a pan palette, and after it hardens, use it just as you would pan paints.

UNITY Placement of design elements in relation to each other in a psychologically satisfying way or to create an aesthetically pleasing whole.

VALUE The relative lightness or darkness of a hue, or of a neutral varying from white to black.

WARM COLORS Colors with a yellow undertone.

WASH A thin translucent layer of diluted color laid over an area of paper too large to be covered by a single brushstroke. Washes can cover most of the paper of a small painting. For a large area, a lot of paint is needed and must be thoroughly mixed for laying the wash. Flat washes have a uniform color with no lines or ripples in paint. Gradated or graded washes are one color that's darker at the top. And variegated color washes have two or more colors. Some artists prefer a sponge to a brush for laying a flat wash over a large area. A wash can be applied to dry paper or

damp paper. Dampening the paper helps the colors blend but makes it less easy to control the paint because it will flow into any damp area.

WATERCOLOR Painting in pigments suspended in water and a binder such as gum Arabic. Traditionally used in a light to dark manner, using the white of the paper to determine values.

WAX RESIST Wax repels water and allows you to block paint or protect a part of the paper where you don't want paint. On smooth paper, wax could block paint completely. Some watercolor paper is not smooth, so wax still allows paint to seep into troughs and create slight speckling or imitate textures.

WET ON DRY A watercolor technique of painting wet color on a dry paper surface.

WET ON WET A watercolor technique of painting wet color on a wet paper surface. The paper can be saturated; use a small dish washtub or your bathroom tub to wet the paper.

WHITES Among watercolor purists, the paper and the water are considered whites. White paint or gouache can be used to produce whites on a dark background.

METRIC EQUIVALENTS

0.63 cm = ¼ inch

1.25 cm = ½ inch

2.54 cm = 1 inch

3.75 cm = 1½ inches

5 cm = 2 inches

10 cm = 4 inches

20 cm = 8 inches

25 cm = 10 inches

30 cm = 12 inches=1 foot

1 meter = 39 inches

1 ounce = 28 grams

1 pound = 448 grams

Standard 140-pound watercolor paper is usually 500 sheets (a ream), each measuring one square meter.

Grammage: 525 grams/square meter

INDEX TO WATERCOLOR PAINTINGS

INDEX